WALTER SICKERT

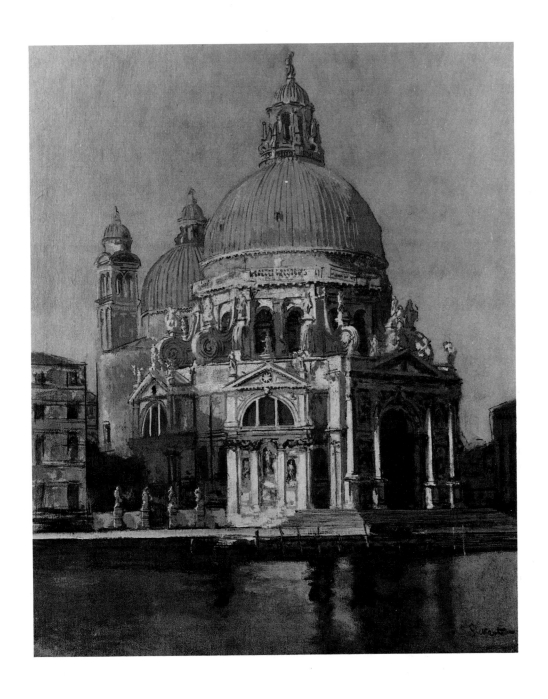

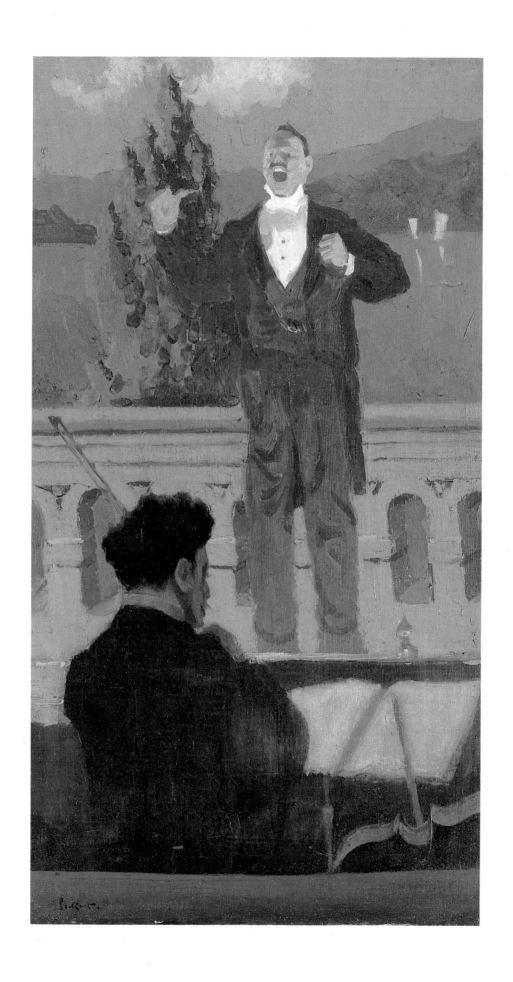

Walter Sickert

Richard Shone

Phaidon · Oxford

Phaidon Press Limited,
Littlegate House,
St Ebbe's Street,
Oxford, OX1 1SQ

First published 1988

© Phaidon Press Limited 1988

British Library Cataloguing in Publication Data

Shone, Richard
 Walter Sickert.
 1. Sickert, Walter Richard—Criticism
 and interpretation
 I. Title II. Sickert, Walter Richard
 759.2 ND497.S48
 ISBN 0–7148–2479–8

Phototypeset by Wyvern Typesetting Ltd, Bristol

Printed in Great Britain by
Hazell Watson & Viney Ltd,
Aylesbury

(*Half-title*) Walter Sickert. *Santa Maria della
Salute, Venice.* c. 1901. Oil on canvas, 59.7 × 48.3
cm. (23½ × 19 in.) Private collection

(*Title*) Walter Sickert. *The Lion Comique.* 1887. Oil
on canvas, 50.8 × 29.3 cm. (20 × 11½) London,
Fine Art Society

1. Philip Wilson Steer. *Walter Richard Sickert.*
1894. Oil on canvas, 59.7 × 29.8 cm (23½ × 11¾
in.) London, National Portrait Gallery

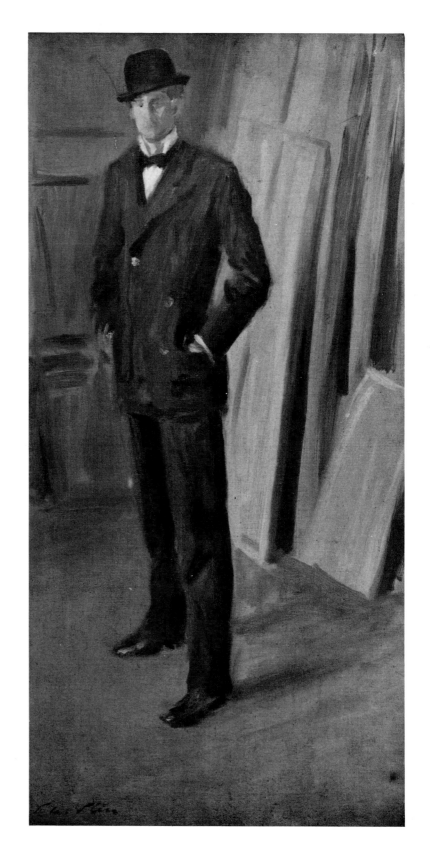

CONTENTS

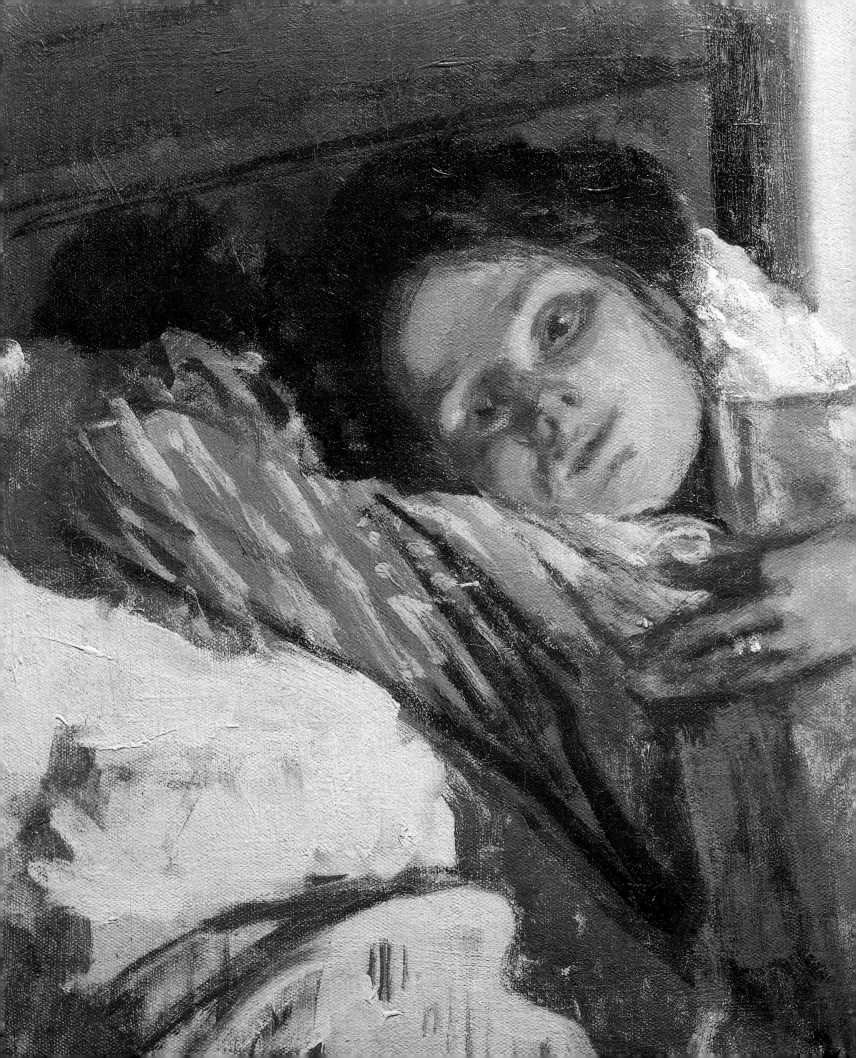

To Daniel Moynihan

2. Walter Sickert. *The Siesta* (detail of plate 5)

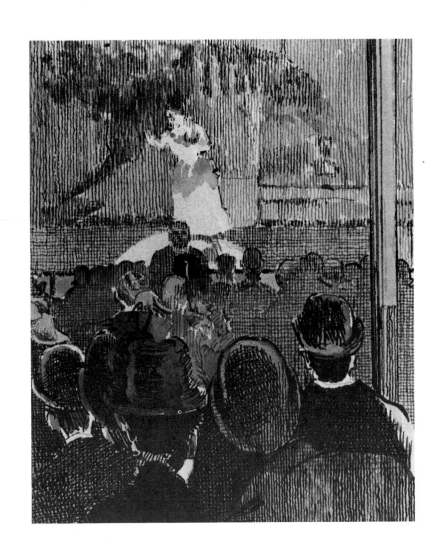

3. Walter Sickert. *Sam Collins, Islington Green.* Pencil, pen and ink and watercolour, 12.1 × 10.5 cm. (4¾ × 4⅛ in.) Private collection

ACKNOWLEDGEMENTS

The author and publishers would like to express their gratitude to Henry Lessore, who as copyright holder, kindly gave permission to reproduce the pictures of Walter Richard Sickert. They also wish to thank warmly the private collectors, some of whom prefer to remain anonymous, and the many public collections, who have allowed works in their possession to be reproduced in this book. The author expresses his gratitude to Gillian Craig and Kate Trevelyan; to Peter Ackroyd; to Robyn Ayres; to Veronica Sekules; to the staff of Islington Public Library; and to Caroline Elam who made most helpful corrections and additions to the typescript. Dr Wendy Baron, fountain of knowledge, has responded most generously to several requests for help in tracing Sickert's pictures, and the author offers her his thanks. In tracing owners and procuring photographs he acknowledges, in particular, the kind help of Richard Burrows, William Darby, William Joll, Matthew Marks, Anthony Mould, Daniel Moynihan, Caroline Potts, Peyton Skipwith, Robert Vousden and Simon Watney.

Special photographic acknowledgement is made to Her Majesty Queen Elizabeth the Queen Mother for Plate 68, and to the following: Aberdeen City Art Gallery and Museums: 27; Trustees of the late Sir Colin and Lady Anderson: 90; Birmingham Museums and Art Gallery: 15, 24, 63, 88; the Provost and Fellows of King's College, Cambridge: 65; the Syndics of the Fitzwilliam Museum, Cambridge: 35; the Cottesloe Trustees: 62; National Galleries of Scotland, Edinburgh: 92; Exeter City Council: 28; Glasgow Art Gallery and Museums: 16, 69; Thos. Agnew & Sons, Ltd., London: Half-title, 2, 5, 6; Browse & Darby Gallery, London: 50, 66, 82; Christie's, London: 56, 57, 64, 80; the Witt Library, Courtauld Institute, London: 93; the Fine Art Society, London: Title, 3, 9, 34, 41, 48, 49; Anthony d'Offay Gallery, London: 13, 33, 54, 61; Michael Parkin Fine Art, London: 96; Sotheby's, London: 30, 37; Manchester City Art Galleries: 21, 52, 60; Lord Methuen: 95; the National Trust Photographic Library: 73; Tyne and Wear Museums Service, Newcastle-upon-Tyne: 17, 23; Museum of Modern Art, New York, Bertram F. and Susie Brummer Foundation: 85; the Metropolitan Borough of Sefton Libraries and Arts Department: 55; Sheffield City Art Galleries: 51.

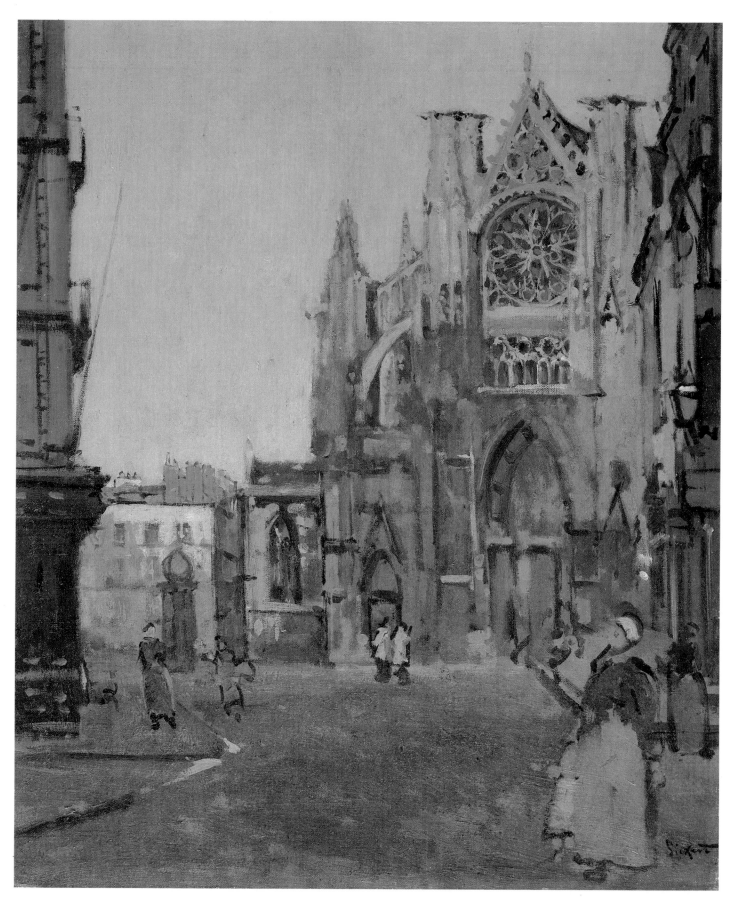

4. Walter Sickert. *St Jacques, Façade.* c.1899–1900. Oil on canvas, 55.9 × 48.2 cm. (22 × 19 in.)
Manchester, Whitworth Art Gallery, University of Manchester

PREFACE

The work of Walter Richard Sickert constitutes the most compelling vision and searching technical achievement of any artist of his generation in Britain. His view of life was often courageous in its expression, stamping the variety of his output with a feeling for humanity that in its intensity, is unusual in modern British painting. He was an alert celebrant of day-to-day existence in aspects both imposing and subtle, both seedy and hilarious. If in this sense he was a realist, it was a realism of a peculiar kind. He shunned the anecdotal traditions of English figurative painting in favour of heightened poetic moments grounded in a watchful appreciation of mundane existence. Famous for choosing 'real life' subjects—clothed and unclothed figures in North London interiors, sparsely lit and rudimentarily furnished—Sickert's realism was as remote from most people's experience as it was from his own. It is a highly contrived construct, answering the painter's complex psychological needs. These shaped the form and mood found in his work, as much as Sickert's vehement reaction against much of the art he saw around him in England when he began his career in the 1880s. Sickert's lack of pointed description or explicit narrative, his grand detachment, enable his images to go on living while so much documentary realism has long since lost its power to move.

Although Sickert is the outstanding English painter of his time, his reputation has been fluctuating and controversial. Understanding the nature of his overall achievement has been difficult, and complicated by the labels of 'realist' and 'latterday Impressionist', often attached to him. That Sickert had ties with the French Impressionist movement is undoubtedly true but its example contributed little to his development. His training and lineage were different and his sympathy, in his practice, was intermittent. Regarded, too, as an *intimiste* sharing qualities with Bonnard and Vuillard, Sickert can be chillingly removed from his subjects, with little of the domestic warmth of his French contemporaries. Only certain superficialities of composition (ultimately derived from Degas) point to this kinship. The one contemporary artist with whose work he seems to share similarities, Toulouse-Lautrec, he apparently disliked. He infinitely preferred the English humorist draughtsmen, such as Leech and Keene, and the German illustrators whose work he loved from his childhood.

If there is Sickert the 'realist', committed, as he wrote, to 'gross material facts', fleeing the drawing room for the hopeless back parlour, the stalls for the gods, there is also Sickert the painter of Venice, of St Mark's and the Rialto Bridge, of the fashionable seafront of Dieppe and the eighteenth-century streets of Bath. Such variety of subject and approach has continued to confuse any sound evaluation of his work. And in recent years, just as that work seemed to be achieving some well-defined position from which it could be viewed with a tidier equanimity, his late painting, from the 1920s to his death in 1942, often based on photographs, has bounded impetuously into the ring, demanding to be seen. Luckily, the re-exposure of such

works has greatly widened Sickert's appeal, locked for too long within the confines of the Camden Town Group, masterminded by Sickert between 1911 and 1913. The text that follows has been deliberately weighted towards the later Sickert, the intricacies of the earlier years having been detailed admirably elsewhere.

The illustrations in this book have been selected with a bias towards Sickert as painter of the human figure in an interior, whether bedroom or theatre or studio. It is through such works that he made his most original contribution to the art of his time; the figure in its appropriate setting ('*someone, somewhere*' as he wrote) was at the heart of his aesthetic conception. In a famous passage from an essay written in 1910 (a year of consternation in English art), Sickert admonished that the 'plastic arts are gross arts, dealing joyously with gross material facts ... and while they will flourish in the scullery, or on the dunghill, they fade at a breath from the drawing-room.' By that date, Sickert was thoroughly immersed in the themes of figures in interiors and conversation pieces which had reached a spectacular point in his Camden Town Murder series and were to culminate in that great non-conversation, *Ennui* (c.1914). But in his first twenty years as a painter, the subject is only sporadically treated, in more conventionally realized portraits and tentative etchings. The first group of works that we instantly associate with Sickert in subject and treatment is his music hall paintings—figures in interiors, to be sure, but drawn from public rather than domestic life. To reach these quintessentially English scenes and explore the synthesis they embody, we must briefly go back to the painter's early, cosmopolitan years.

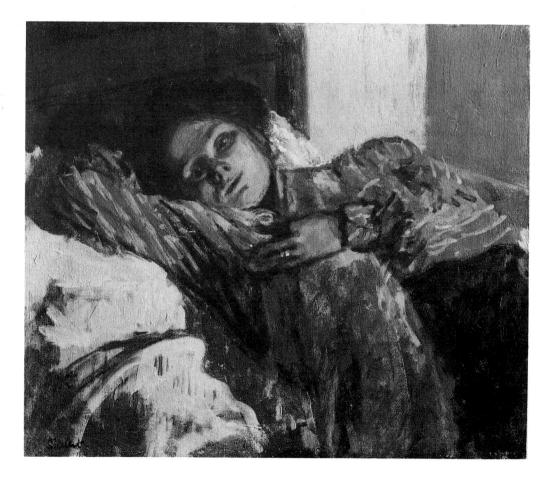

5. Walter Sickert. *The Siesta*. 1903–4. Oil on canvas, 38.1 × 45.7 cm. (15 × 18 in.) Private collection

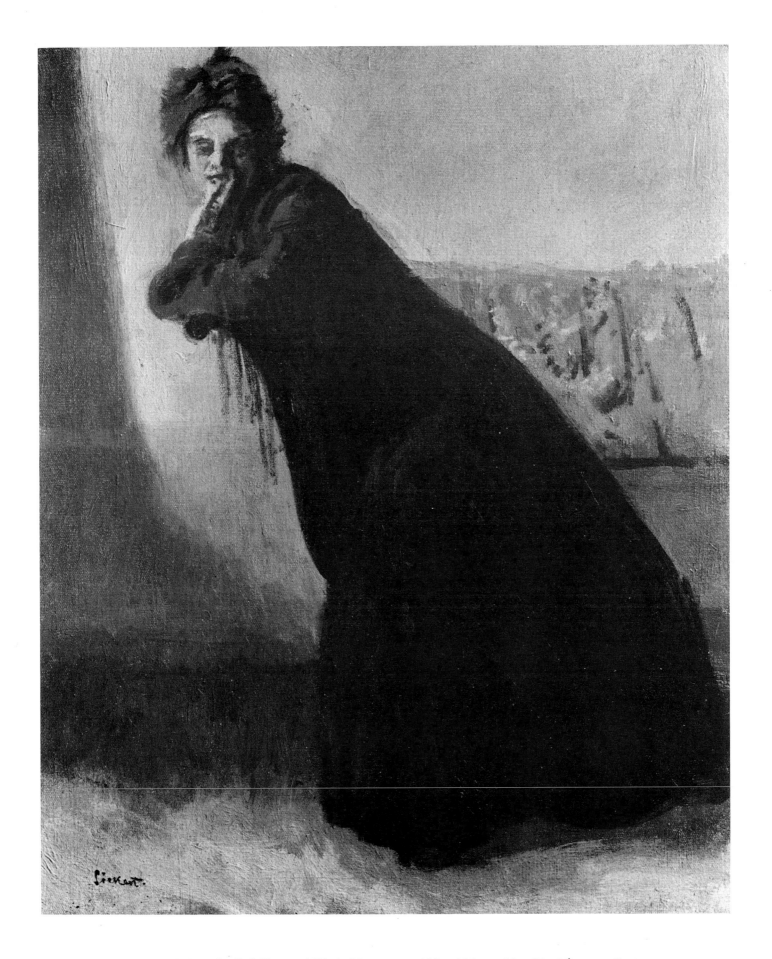

6. Walter Sickert. *Le Châle Vénitien.* 1903–4. Oil on canvas, 45.7 × 38.1 cm. (18 × 15 in.) Private collection

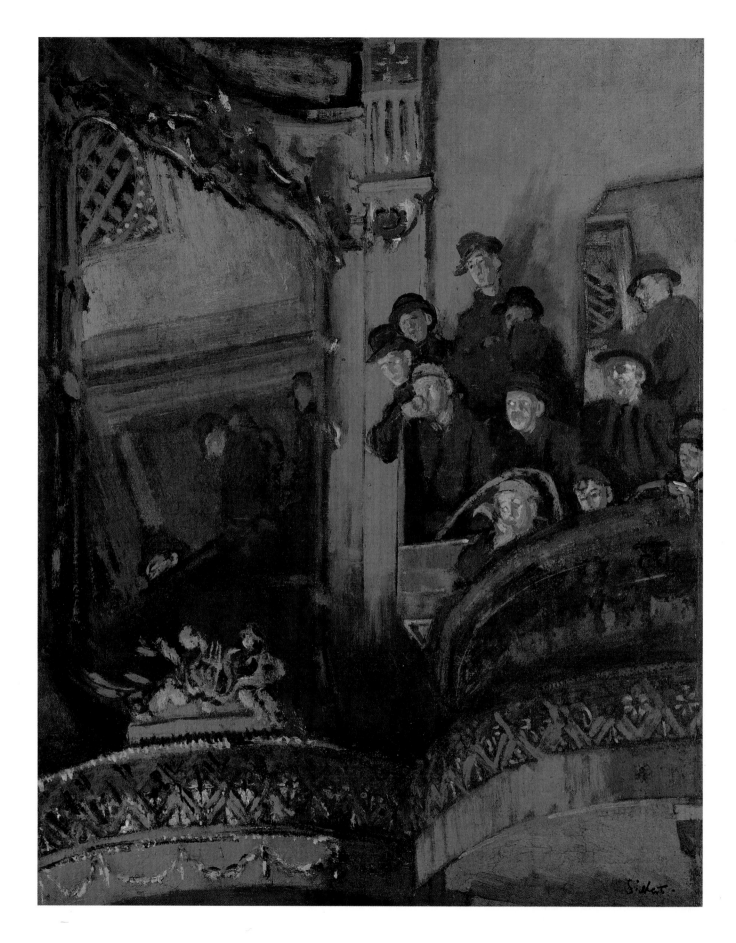

7. Walter Sickert. *The Gallery of the Old Bedford.* c.1894. Oil on canvas, 76.2 × 60.4 cm. (30 × 23¾ in.) Liverpool, Walker Art Gallery

THE MAKING OF A REPUTATION

'I have never forgotten anything he said to me,' Sickert wrote of his father, Oswald Adalbert Sickert. Not only was Sickert's father a painter and illustrator (and a good musician), but so too was his grandfather, Johann Jürgen Sickert (1803–64), a Dane working in Altona, near Hamburg, employed in the household of Christian VIII of Denmark. Johann Jürgen's son Oswald (1828–85) studied in Copenhagen and Munich and in 1852 worked for six months in Paris under Thomas Couture, at that time the exasperated teacher of Manet. In 1859 Oswald Sickert married and joined the staff of the Munich-based humorous magazine *Fliegende Blätter*, as a black-and-white artist. Sickert later recorded his joy at the weekly arrival in the household of the magazine's latest issue, though Sickert *père* would sometimes grumble at the licence taken by the wood-engraver with his drawings.

Elinor Sickert, Oswald's wife, had a remarkable parentage and upbringing as the illegitimate daughter of an Irish dancer (who, like so many, 'disappeared to Australia') and Richard Sheepshanks, secretary of the Royal Astronomical Society and a fellow of Trinity College, Cambridge. Sheepshanks assumed the role of guardian to the child (who took her mother's surname of Henry) and sent her abroad, as soon as possible, to be educated, at first in Dieppe and later in Altona where she met her future husband. Complications were to follow, and it was ten years before the couple were married (in England); they were able to establish a home soon afterwards in Munich. It was there that their son Walter Richard was born (31 May 1860), the first child in a family of six.

In 1868 Oswald moved with his wife and four children to England, eventually taking British nationality, and continued to earn his living as an artist. The Sickerts lived in Notting Hill, London (where two more sons were born) and later in Pembroke Gardens, Kensington. Before their arrival in England the Sickerts had spent some time in Dieppe, and it was to this Normandy port and summer resort that the family returned on several occasions. It was there that the young Sickert first began to learn French and that the cultured, lively family to which he belonged made friends and acquaintances among the French residents and stream of English visitors. The setting of Sickert's early years is evoked in the memoirs of his sister Helena, the only record of that period of his life. In *I Have Been Young*, Helena Swanwick, as she later became, writes of the meetings in London with the Burne-Jones and Morris families and of the Sickerts' friendship with Oscar Wilde, of the sarcastic tongue of the taciturn Oswald and of the mixture of convention and independence in her authoritative mother.

Sickert was a precocious child to whom the study of languages came easily and in whom a love of literature, particularly drama, emerged in his earliest years. Drawing, acting and musical performance were the diet of family life and Sickert was a natural leader among the six children. After attending three schools between his arrival in

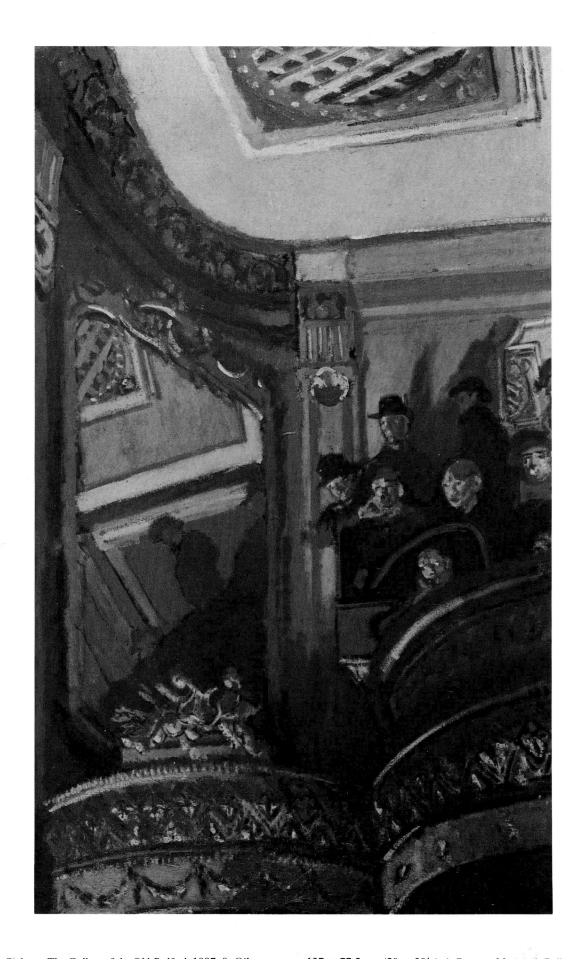

8. Walter Sickert. *The Gallery of the Old Bedford.* 1897–8. Oil on canvas, 127 × 77.5 cm (50 × 30½ in.) Ottawa, National Gallery of Canada

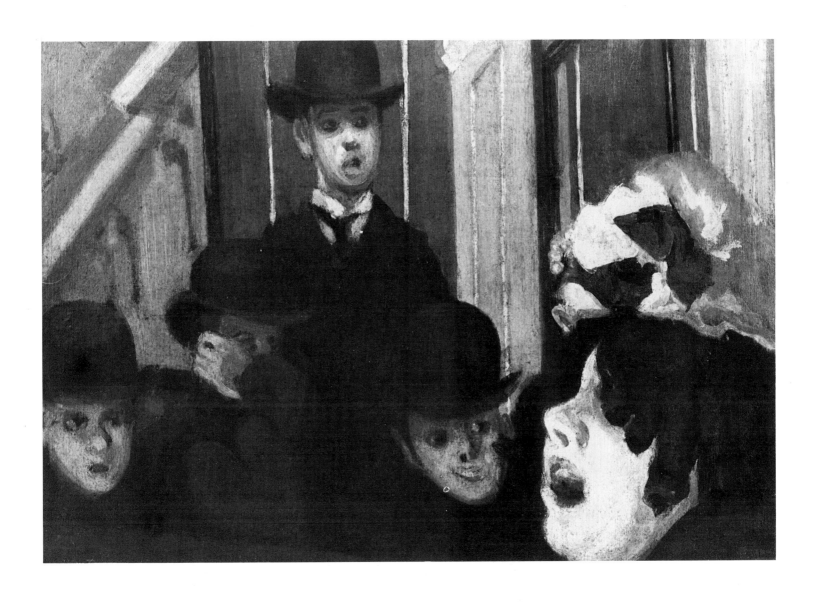

9. Walter Sickert. *Bonnet et Claque. Ada Lundberg at the Marylebone Music Hall.* c.1887. Oil on canvas, 41.9 × 59.7 cm. (16½ × 23½ in.) Private collection

England and 1875, Sickert went to King's College School, matriculating after two years with a passion for Shakespeare, poetry and Greek and Latin literature. In his late teens, he was tall and fair, extremely good looking with high spirits, energy, charm and a ruthless egoism, all of which augured well for the career of acting which he chose to pursue. He began to appear in walk-on parts and minor roles in London (with Henry Irving's company, for example, at the Lyceum Theatre) and on tour in the provinces. His brief career culminated at Sadler's Wells as Demetrius in *A Midsummer Night's Dream* in 1880, though there were further engagements in the following year. Although Sickert's professional relationship with the stage then ceased, the theatre dominated the rest of his life. It became the subject in various ways of whole groups of works, from the London and Paris music halls, through depictions of cabaret and revue to the long series of theatre paintings from the 1930s. Theatrical terms, the names of performers from several generations, and quotations from Shakespeare peppered his conversation and critical writings. The ostensible subject matter of many of his paintings is often dramatic, figures arranged with a conscious regard for the possibilities suggested by a particular *mise en scène* (in *Amphytrion*, for example, or the well-known *Suspense* in the Ulster Museum, Belfast). The elaborate artifice of the stage, the juxtaposition of figures for psychological impact, the chiaroscuro obtained by lighting from several sources, all were contributory factors to Sickert's conception of portraiture and interiors. His own appearances in his work, such as Lazarus, an inveterate gambler, a rural dean or a domestic bully, parallel the often noted, rapid changes in Sickert's looks and clothes, enthusiasms and studios, as if by acting a variety of roles he ensured his essential character remained inviolate.

Following Sickert's abandonment of the stage, it would be correct to say that he returned full time to painting, for his earliest works (not extant) were contemporaneous with his acting career. In 1881–2 he attended the Slade School of Fine Art under Alphonse Legros, took lessons from his father's friend Otto Scholderer (then living in London) and improved his acquaintance with Whistler, whom he regarded at the time as the 'only painter alive who has . . . immense genius'. Voiced in 1879, this opinion preceded Sickert's introduction to the work of Degas,

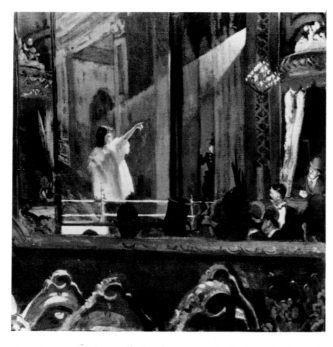 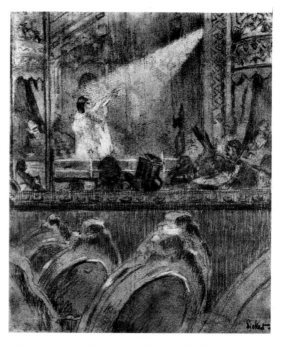

10. Walter Sickert. *Little Dot Hetherington at the Bedford Music Hall.* c.1888–9. Oil on canvas, 61 × 61 cm. (24 × 24 in.) Private collection
11. Walter Sickert. *Joe Haynes and Little Dot Hetherington at the Old Bedford Theatre* c.1889. Chalks, watercolour and charcoal, 31.75 × 26.7 cm. (12½ × 10½ in.) Private collection

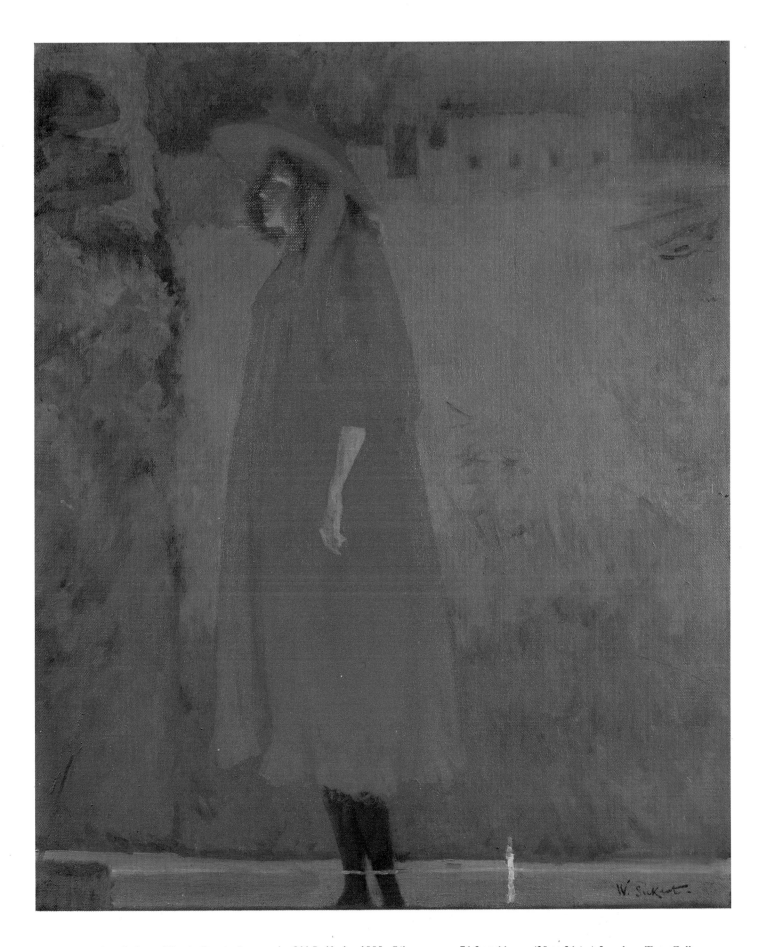

12. Walter Sickert. *Minnie Cunningham at the Old Bedford.* c.1889. Oil on canvas 76.2 × 66 cm. (30 × 26 in.) London, Tate Gallery

Renoir and Pissarro. Although certainly aware, through his father and Scholderer, of current German art, Sickert's sympathies were immediately given to French art and to the work of painters in England who had studied in France.

Within a few months the force of Whistler's personality provoked Sickert into leaving the Slade and becoming the American painter's pupil and studio assistant in Tite Street, Chelsea. The alliance was immediately fruitful, Sickert establishing that passion for technical knowledge which became the obsession of his whole career, the heart of his critical writings and his teaching from which radiated all other considerations. '*Elève de Whistler*' is written over Sickert's earliest works, from the fluent low-toned beach scenes and crepuscular shopfronts to the slight etchings of London, in Whistler's elliptical style. Sickert's fellow assistant, Mortimer Menpes, was to write later in his *Whistler as I Knew Him* (1904) that 'we copied Whistler in every detail If we etched a plate we had to etch it exactly on Whistlerian lines. If Whistler kept his plates fair, ours were so fair that they could scarcely be seen. If he adopted economy of means, using the fewest possible lines, we became so nervous that we could scarcely touch the plate lest we should overelaborate.' Such subservience as this suggests, in someone of Sickert's independent and roving intelligence, was bound to break. Ironically it was Whistler himself who opened the door for his pupil's escape, by giving him in 1883 a letter of introduction to Degas in Paris. Sheer persistence on Sickert's part enabled him to meet the artist and see his own work and his collection. Two years later Sickert encountered Degas in Dieppe and the Frenchman included the tall young Englishman in a group portrait of friends.

From this new and exhilarating friendship there followed a critical examination of Whistler's methods and subject matter and the beginnings of a veneration for Degas which remained unclouded for the rest of Sickert's life. But it should be stressed here that the eventual eclipse of Whistler by Degas was not, for Sickert, simply a matter of aesthetic repudiation. After all, there were several points of contact between Degas and Whistler themselves and the influence of the latter can be detected even in the work of Sickert's old age (in the series of shopfront pictures, for

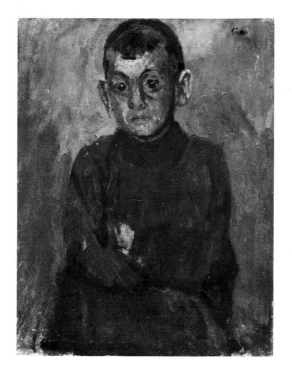

13. Walter Sickert. *One of Madame Villain's Sons.* c.1904. Oil on canvas, 51.1 × 40.9 cm (20⅛ × 16⅛ in.) Private collection

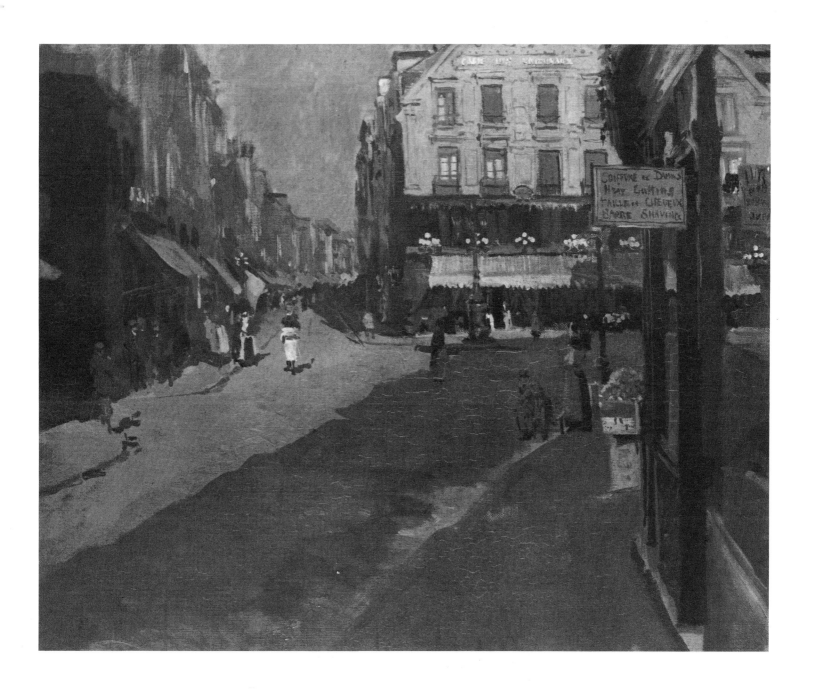

14. Walter Sickert. *Café des Tribunaux*. c.1890. Oil on canvas, 60.3 × 73 cm. (23¾ × 28¾ in.) London, Tate Gallery

example, and the slim format of full-length, life-size portraits). It was more a question of a conflict of personalities. The witty, vain and masterful Whistler demanded loyalty, and when Sickert transferred his allegiance, Whistler was outraged. 'My Walter, whom I put down for a minute and who ran off', he contemptuously exclaimed to John Lavery. The friendship dissolved, eventually coming to an end in 1897 over an absurd libel action on the definition of lithography. Thoroughly at home in the witness box, Whistler referred to his one-time pupil, by then a commanding figure in the English avant-garde, as an 'insignificant and irresponsible person'.

For Sickert, the meeting with Degas was crucial in several ways. It brought him at last into immediate contact with the modern movement in France, forcing him to see in a clearer perspective the restrictions of contemporary art in England; it established his relations with several French painters, dealers and critics; and it allowed Sickert access to the real nature of his ambitions, confirming his dissatisfaction with the excessive refinement of Whistler's practice. 'His whole work,' Sickert wrote years later in one of his trenchant summaries of Whistler's achievement, 'was the adoring homage of the New World to the Old. His career, the second rape of Europa by a Southern gentleman in impeccably laundered ducks.' Degas's frank depiction of the world around him, his tenacious exploration of the daily life of midinettes, laundresses, diseuses and dancers, gave Sickert the confidence to pursue his own instincts. How else can we account for the sudden, unexpected mastery of his music hall paintings of the late 1880s? Influences remain of course, but the works are already distinct in their method of production as much as in the individual temperament they disclose.

The choice of the music hall as subject matter for painting was certainly new in England, though contemporary writers and illustrators were already beginning to celebrate this particularly English form of entertainment. The music hall had its roots in the London 'song and supper-rooms', in licensed variety saloons and the small concert halls attached to taverns. Perfunctory turns and songs were carried on against a noisy foreground of eating and drinking. By the mid-nineteenth century the musical hall was well established, with its acts running continuously from early evening to midnight, introductions coming from a loquacious chairman who faced the audience, the musicians sitting behind him. Towards the end of the century, grander, purpose-built music halls made their appearance, managements outdoing each other in the elaboration of their programmes and the gilt, plush and plasterwork of their theatres' interiors. But in the outlying halls, away from the West End, something of the older saloon atmosphere persisted, of boisterous working-class audiences who were uninhibited in their reactions to the business on stage. They tended to be overawed by the spacious trappings and more seemly conduct of the new (and pricier) theatres around Piccadilly and Leicester Square. The songs and sketches ranged between cockney humour and saccharine sentiment, spiced, by the best performers, with a worldly cynicism. Sickert, too, avoided the more recent variety theatres (such as the Alhambra or the Holborn Empire). He haunted the Old Bedford, Camden Town, attached to the Bedford Arms, Gatti's, known in the 1880s as Gatti's Hungerford, in Villiers Street, where Rudyard Kipling, who lodged in the street, by looking from his window could see directly to the stage through the fanlight of the theatre door, and the Middlesex, next to the Old Mogul Tavern in Drury Lane. He studied the teenage Marie Lloyd at the Oxford music hall and the 'lions comiques' at Collins's, Islington Green (Pl. 3). Night after night he went to the Marylebone to hear Ada Lundberg deliver herself of 'All through sticking to a soldier' and the classic cockney drunk of 'I'm all right up to now'. In small sketchbooks he would make innumerable studies of the artistes, audience and theatre architecture, now focusing his attention on the orchestra or some extravagant plumed hat in the stalls, now on the tenebrous figures in the gallery.

Degas's admonition that a painter should work from observations, studies and memory, away from 'the

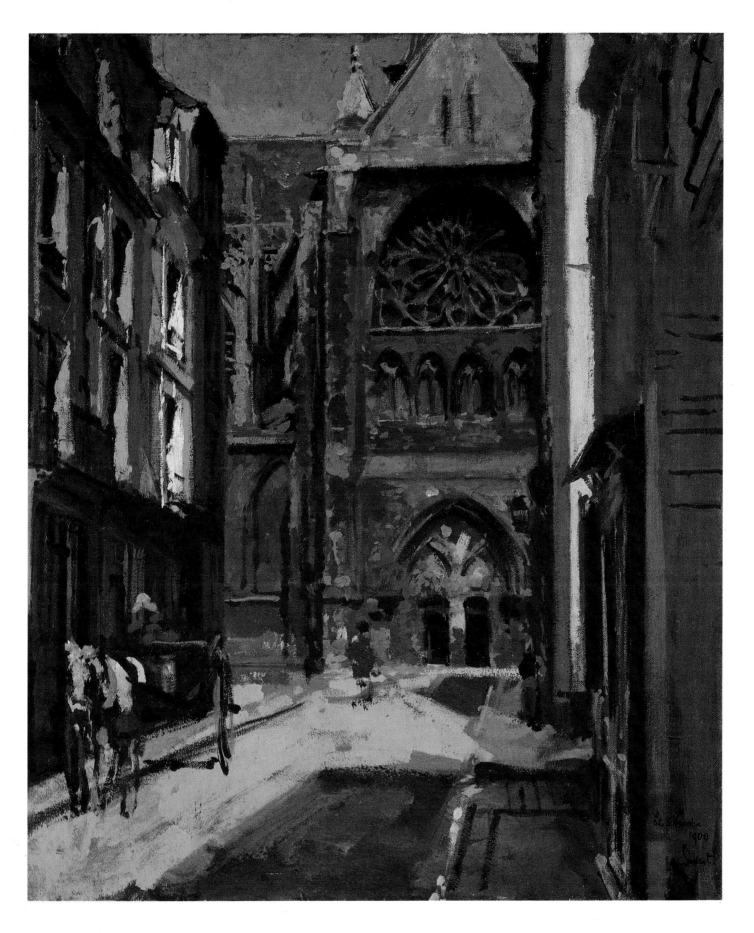

15. Walter Sickert. *La Rue Pecquet.* 1900. Oil on canvas, 54.6 × 45.7 cm. (21½ × 18 in.) Birmingham, City Art Gallery

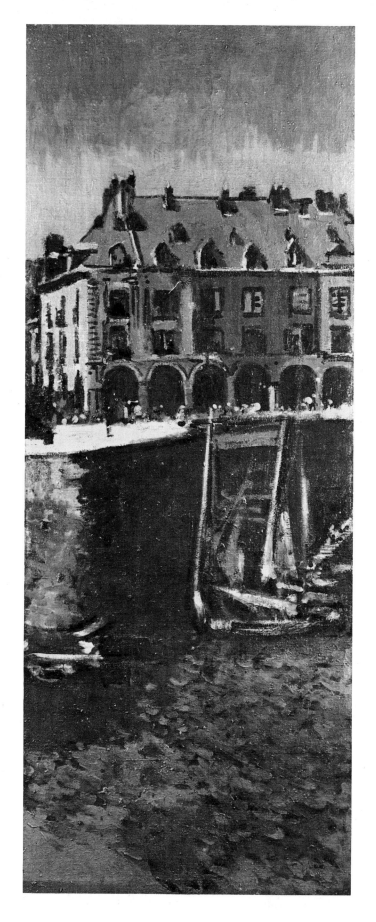

16. Walter Sickert. *La Darse.* c.1902. Oil on canvas, 151.1 × 53.3 cm. (59½ × 21 in.) Glasgow, City Art Gallery

17. Walter Sickert. *St Mark's Square, Venice* (detail of Plate 23)

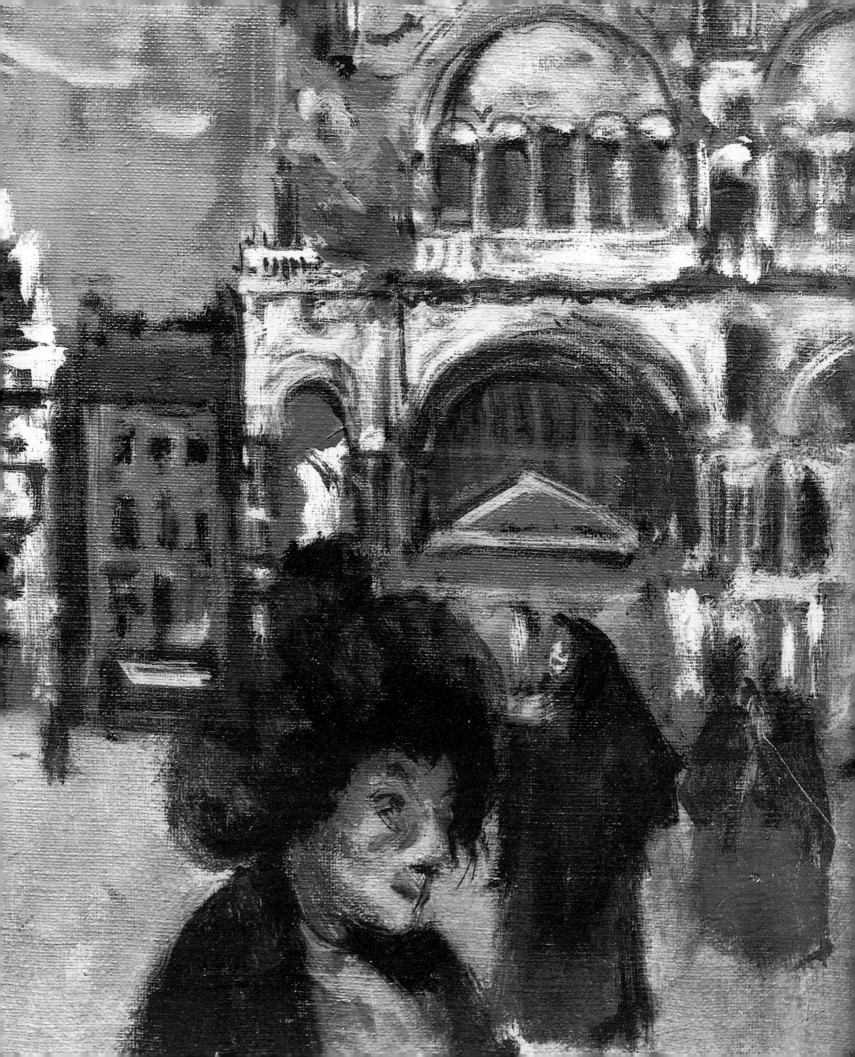

tyranny of nature', could hardly have found a more zealous adherent. Admittedly, the process had been set in train by Whistler at the start of Sickert's career. But what animated Sickert to pursue this intense period of study was the finding of a personal subject matter with which he could be identified. It satisfied his notions of freeing art from the gentilities of the drawing room and the artificiality of the north-lit studio model. The complexity of the theatre, its seat rows and curving boxes, its changing light and reflecting mirrors, appealed to (and encouraged) his increasingly sophisticated sense of form and enhanced his delighted reactions to the performance he had paid fourpence to see.

It is in these works that Sickert began that method of proceeding—of how to net his particular view of reality—which was to occupy him for the rest of his life. Not that he was always consistent; certainly among these first music hall paintings there are differences of approach. There is the emphatically painted, cleanly coloured *Lion Comique* (Title) and the filmy, Whistlerian handling of paint in Katie Lawrence at Gatti's. *The Lion Comique* and *Bonnet et Claque* (Pl. 9) show Degas's influence in their subject and organization rather than in their colour and handling. In its modest way, the bragging, cockney gesture of the 'lion comique', Fred Albert, does for the English music hall what Degas had done for the Parisian *café-concert* in *Le Café-concert aux Ambassadeurs* of about 1876, with its stout artiste swathed in red, arm flung out in provocative supplication. And the open-mouthed singer in *Bonnet et Claque* echoes Degas's *Chanteuse au gant* of 1878. The close feeling Sickert had for this series of Degas's work is confirmed by his possession of the monotype pastel *Mlle Bécat au Café des Ambassadeurs*. But when we turn to the painting of *Little Dot Hetherington* (Pl. 10) we find a work of consummate achievement, assured in its tonal changes, complex in structure (for we are seeing the greater part of the scene depicted as a reflection in a mirror) and completely contemporary in image and mood. The fact that the girl is singing 'The boy I love is up in the gallery' only enriches the atmosphere Sickert has established, for it was one of the most popular songs of the period (and helped, at this time, to launch the career of Marie Lloyd). In this painting and in the Katie Lawrence we catch for the first time Sickert's profound interest in 'the moment', in the ghostly adumbration of time passing, of a figure in action momentarily suspended by all the elaborate artifice of the painter's craft. It is all the more remarkable that Sickert was able to capture this among the gilt, tobacco smoke and oom-pah-pah of the music hall, with Bessie Bellwood hurling invective at hecklers or Katie Lawrence stoutly maintaining that 'She looked a perfect lady'.

Sickert's achievement was recognized by friendly viewers at the time, for example, William Rothenstein, Max Beerbohm and George Moore. But the paintings also drew, from less convivial commentators, accusations of deliberate vulgarity. Even the sympathetic if upright critic D. S. MacColl found he had to make some excuses for Sickert's taste for the stage and its reprehensible footlights. But, devoted as Sickert was to the urban scene, what else should he paint? What, in the art of his time, was the right subject matter? It was the eternally vexing question, one to which Sickert repeatedly returned in his critical writings and reviews over the following decades.

With the example before him of Degas at the *café-concert*, Manet at the Folies-Bergère and Renoir at the *bal musette*, Sickert's choice of the music hall seems straightforward. He was not an imaginative artist in the sense that he could tackle allegories, romantic figure compositions and sentimental genre. They were inimical to his temperament as a painter, even if, in print, he professed the highest admiration for many of their exponents. He was neither a realist with a finicky programme of social pieties nor a suave society portraitist, a role which lured some of his contemporaries into its insidious net.

In one of his most substantial pieces of writing, a contribution to a book on Jules-Bastien Lepage (1892) on the theme of 'Modern Realism in Painting' (written in 1891), Sickert announced his admiration for Millet, Whistler, Degas and the drawings of Charles Keene. He reiterates his conviction that works of art are produced from

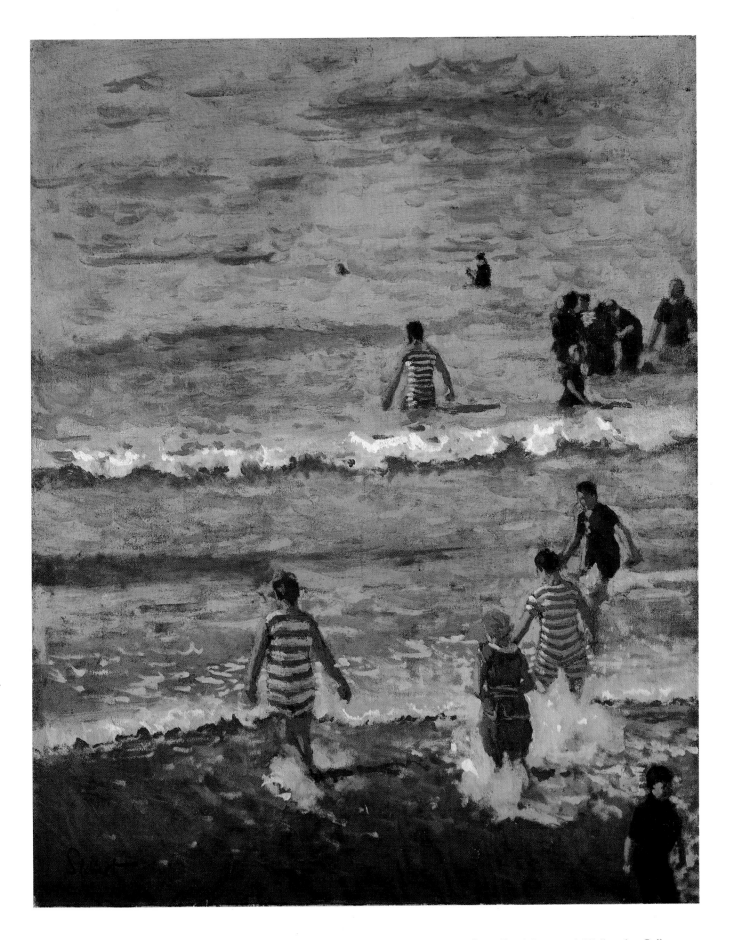

18. Walter Sickert. *The Bathers, Dieppe.* 1902. Oil on canvas, 131.5 × 104.4 cm. (51¾ × 41⅛ in.) Liverpool, Walker Art Gallery

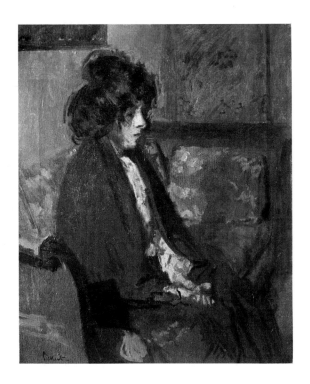

19. Walter Sickert. *La Giuseppina*. 1903–4. Oil on canvas, 62 × 53.2 cm. (24¼ × 21 in.) New Haven, Yale Center for British Art

accumulated observation rather than a catalogue of 'tiresome little facts'. It was the business of modern painters to engage with the life around them, that they should 'paint their brother, whom they have seen, before they elect to flounder perennially in Olympus.' It was an old battle cry in France but a relatively new one in England. It ranged Sickert alongside a few of his contemporaries in the 1880s and 1890s in begging, in one sense, for wider margins of expression. At the same time, it placed Sickert intellectually with several writers of the period who expressed their enthusiasm for the city. If Sickert never went as far in this exploration of urban mood as did poets such as Lionel Davidson or Arthur Symons, and shared little of the more personal aspects of such contemporaries, his antithetical and provocative writing has similarities with Whistler, Wilde and Beerbohm. Sickert always had about him a detached cheerfulness and his pose, if any, was neither that of the 'decadent' dandy nor of youth in capricious revolt. Though appearances might suggest otherwise, he was supremely serious, workmanlike and independent. Years later he was to write to the young painter Nina Hamnett: 'The one thing in all my experience I cling to is my coolness and leisurely exhilarated contemplation. . . . Let this advice be my perpetual and most solemn legacy to you.'

Sickert's development was cautious, as the words just quoted suggest. It was not until the very end of the century that he began to use a more varied and expressive brushstroke and choose colour which, if not audacious in contemporary French terms, was less limited than before. Whistlerian tonalities continued to echo through his work; they were 'an unconscionable time dying'. But the period between 1898 and 1905, which Sickert spent in Dieppe and Venice, saw a recasting of his work in almost every way. A new group of subjects included the urban landscape, and nudes and figures in interiors strengthened the psychological impact of his work; inseparable from them were technical experiment and advance. Sickert, in his early forties, was about to embark on a major phase of his career.

But why, just as he was gaining a solid reputation in London, did he leave to bury himself in Dieppe? And why a few years later, when he was becoming known in Paris and had shown in Brussels and Venice, did he return to London? The reasons of course are complex and interrelated. By the late 1890s, Sickert's ten-year affair with the music hall had come to an end (though the old flame was to revive several years later). In 1895 he had visited Venice and began there a series of 'topographical' paintings, mainly of St Mark's and its vicinity, which whetted his appetite for further exploration; it was a change in every way from the London interiors and he needed something new. At the same time, his personal life was unhappy. In 1885 Sickert had married Ellen Melicent Cobden (1848–1914), whose father was the radical M.P. at the centre of the Anti-Corn-Law League. She was intelligent and vivacious, admired by Charles Keene, Whistler (who painted her on several occasions) and Sickert's family and friends; she introduced her husband to possible clients and patrons in the political world of the Cobdens, including Charles Bradlaugh, whom Sickert painted. The marriage lasted about a decade before foundering on the rocks of Sickert's continual adultery and chronic independence. They separated in 1896 and were finally divorced in 1899. Ellen Sickert had money; Sickert himself had none and when the separation came he was naturally thrown on his own resources. He taught evening classes at a private school in Victoria and intensified his activities as a journalist. In the year between his separation and his departure for Dieppe in 1898, there came the trivial trial, already referred to, over the exact nature of lithography, brought about by an article Sickert had written in the *Saturday Review* (December 1896). Joseph Pennell, the artist and follower of Whistler, brought the libel action against Sickert and the editor of the paper, Frank Harris. Pennell won ('Legally there can be no doubt that the verdict was just,' wrote Sickert) and was awarded £50 damages. It was 'vastly enjoyable and amusing' according to Sickert but rankled perhaps more than he

20. Walter Sickert. *Mamma Mia Poveretta*. 1903–4. Oil on canvas, 45.7 × 38.1 cm. (18 × 15 in.) London, private collection

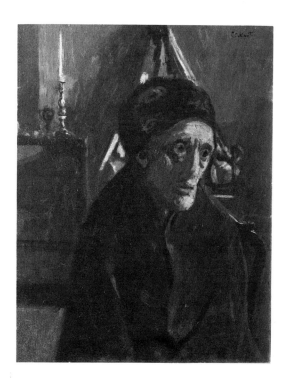

admitted. Certainly it ended his friendship with Whistler and probably sharpened his desire to get away.

In the autumn of 1898 Sickert moved to Dieppe. In the following year he gave up his London studio at 13 Robert Street (the first of his North London studios), had some of his possessions sent to him in Dieppe and settled at nearby Neuville with a mistress and her children (Pl. 13). This was Mme Villain, a fishwife of striking appearance and red hair, whom Sickert was to paint on several occasions; he almost certainly had a son, Maurice, by her and their liaison lasted five or six years.

Although Sickert's ties with Dieppe went back to his childhood and he was a well-known figure there, the liberal cosmopolitanism of the place allowed him to choose his own way of life. His social range was infinitely accommodating and he passed easily from the fishing people of Le Pollet to the more exigent company of Lady Blanche Hozier. Deceptions about his unconventional domestic life were unnecessary and the advantages of living a little way outside Dieppe were soon apparent. He continued his practice of making annotated drawings and *pochades* (panel sketches in oil no larger than about seven by nine inches) and painting from them in his studio. He turned his whole attention on the streets and buildings of the town, occasionally venturing on views of the cliffs or of the landscape inland. There are almost no portraits from this period (attempts at earning a living by portraiture in London had fortunately defeated him) and only towards the end of his residence in Dieppe do we find paintings of nudes in interiors.

In Dieppe, the church of St Jacques became the most important presence in Sickert's evolving record of the town. Sometimes it is viewed head-on along the rue Pecquet, glimpsed down the rue Notre Dame or ambushed from behind in the rue de la Boucherie; or shown with its tower and dome catching the evening sun above the shadowed arcades of the Quai Duquesne. The rapid succession of windows down the side of a street, the punctuation of chimney and window on mansard roofs, the progression of the quayside arcading, all appealed to Sickert's sense of topographical nicety. Low-toned colour in buildings and foreground shadows is often relieved by flatly painted, clear skies; Sickert's tonal modulations (over a grey underpainting) achieve immense subtlety in many of the late afternoon, early evening views (*St Jacques, Façade*, Pl. 4). Forms are indicated by drawn lines, usually in black, often interrupted along their length; such pauses of the hand evoke light and shade moving across buildings, figures passing along a street, across a square. House fronts, often parallel with the picture plane, flat skies and open foregrounds frequently suggest stage sets, with passers-by as extras and the lighting sometimes contrived to a pitch of theatrical definition. This dramatic element becomes even more evident in his Venice paintings of 1900 and 1901.

But for all their nuances of mood and discriminating technique, there is something missing from the Dieppe paintings. Yes, we say, here is Sickert on his best behaviour, personal, charming, engagingly restless as he stalks St Jacques from all sides in all weathers. Certainly he has found a voice of his own, rid himself of stale Whistlerian odours and avoided any slavish attention to his seniors in France (though we are sometimes reminded of Sisley in Moret). But aren't some of the pictures a little too well appointed, too finely balanced between spontaneity and solidity? For all their accents of lively detail, they seem to lack that robustness of vision which had stamped the music hall paintings and which was to return with the Venetian figure paintings of 1903–04. If the depictions of Gatti's and the Old Bedford had raised the eyebrow of propriety, much worse was to follow as Sickert explored at first tentatively and then eagerly embraced, the subject matter of some of his finest works—the nude on the bedstead, dishevelled *puttane* in conversation, eventually broadening to include, as he wrote, the 'enchained comedy or tragedy' of 'the ways of men and women'.

Sickert had first visited Venice in 1895. He was there in the autumn of that year with his wife, and in 1896

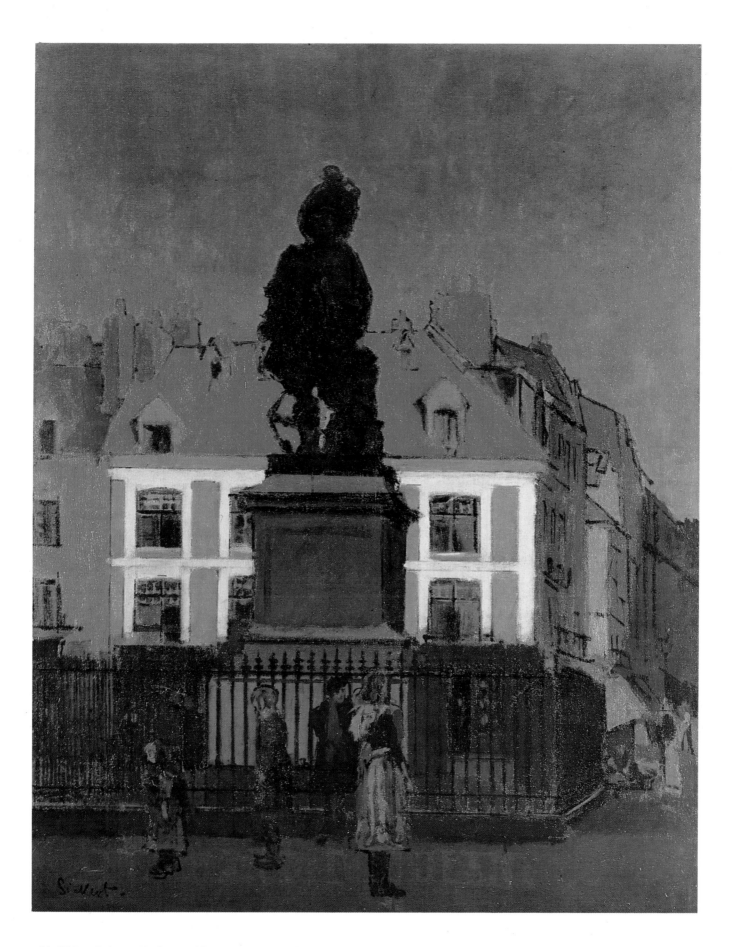

21. Walter Sickert. *The Statue of Duquesne, Dieppe.* 1902. Oil on canvas, 131.6 × 104.8 cm. (51⅞ × 41¼ in.) Manchester, City Art Gallery

alone (at 940 Calle dei Frati, rooms he retained until 1904). He stayed there in the summer of 1900, from January to July 1901 and, his last and longest visit, from the autumn of 1903 until the summer of the following year. He was welcomed into the international society of the city as evoked by Henry James, lunching and dining with the Curtises in the Palazzo Barbaro, with the Fortunys, the redoubtable ladies of the Palazzo Dario, Mrs Gardner of Boston and the transitory population of writers and painters which included Henri de Régnier and Arthur Symons.

But this was not the world Sickert took as his subject (unlike Sargent, for example, in his *Interior in Venice* of 1899). It is true that on his earlier visits the famous sites had attracted him as they had countless other painters: St Mark's, in numerous versions, the Salute, the Rialto Bridge, the Campanile and the Palazzo Ducale. And there is one splendid, unusually free interior from his 1896 visit, of the gleaming basilica of St Mark's looking towards the high altar. But on his last visit he developed a new subject matter which was to occupy him, with variations, for the next twenty years—the figure in an interior.

In Venice Sickert confined himself to one- and two-figure compositions, usually clothed models in the Calle dei Frati apartment with its floral patterned couch, 'beribboned' washstand, chest of drawers (surmounted by a mirror and candlesticks), two beds and sonorous fall of light. His most frequent models were the sharp featured La Giuseppina, her friend Carolina dell'Aqua and one or two others, including La Giuseppina's mother, the wrapped and staring crone of *Mamma Mia Poveretta* (Pl. 20). No men appear (save occasionally Sickert himself); it is a world of women in the traditional role of artist's model. Sometimes they are seen in a moment of purring self-absorption or, in the two-figure works, of desultory gossip or confidential quiet as in *Le Tose* (Pl. 22). Foreshadowing a future theme is *Conversation*, which shows a reclining nude woman talking to a seated clothed one; a variation on this motif is the *Fille Vénitienne Allongée,* a painting that the Musée de Rouen, some years ago, apparently found too risqué to exhibit. Just occasionally, we find Sickert's models in the open air, such as La Giuseppina glimpsed in the Piazza San Marco (Pl. 23) or Inez going about her business on the Zattere, looming up against San Giorgio Maggiore in the distance. Sickert may have used photographs, but more likely contrived such works in his studio in Dieppe or London, from studies made in Venice.

What can we tell of Sickert's attitude to the nude at this important moment in his development, and, by implication, of his treatment of the nude in years to come? He liked his model to be doing something, to be seen in a familiar context. The nude was not to be an exercise in idealism, prettiness, seductiveness—Degas, above all, had taught him that. He had known from the start that the nineteenth-century Salon nude was an 'obscene monster' with, in Huysmans's words, 'a pair of buttocks made of pink, oiled muslin and lit from inside by a nightlight'. Sickert's models were rarely chosen for their beauty of face or figure (an exception, perhaps, is Blanche in Paris in 1906); they were professionals on whom Sickert cast an objective and sometimes merciless eye, though his was never quite as chaste as was Degas's. There was a world of difference for Sickert between the 'nude' and the naked woman dressing, washing, lying down or sitting in her own surroundings (as construed by Sickert). He disliked the 'fussy and self-conscious pottering over female charms' which blighted much late Victorian painting and even the nudes of his friend Wilson Steer. He faltered too before Ingres's *Bain Turc*, which had about it 'something absurd and repellent, a suggestion of a dish of macaroni, something wriggling and distasteful'. Sickert envisaged the nude figure as part of everyday existence and, paradoxically, used all the artifice of a stage manager to procure just that effect. A paid model in a rented room with all the carefully chosen paraphernalia of washstand, chamberpot, dingy curtains and iron bedstead was his equivalent of Degas's constructed studio-bathroom, or, at a later date and at another extreme, Matisse's personal harem in Nice. The contrived realism of figure and setting, expressed through Sickert's wrought

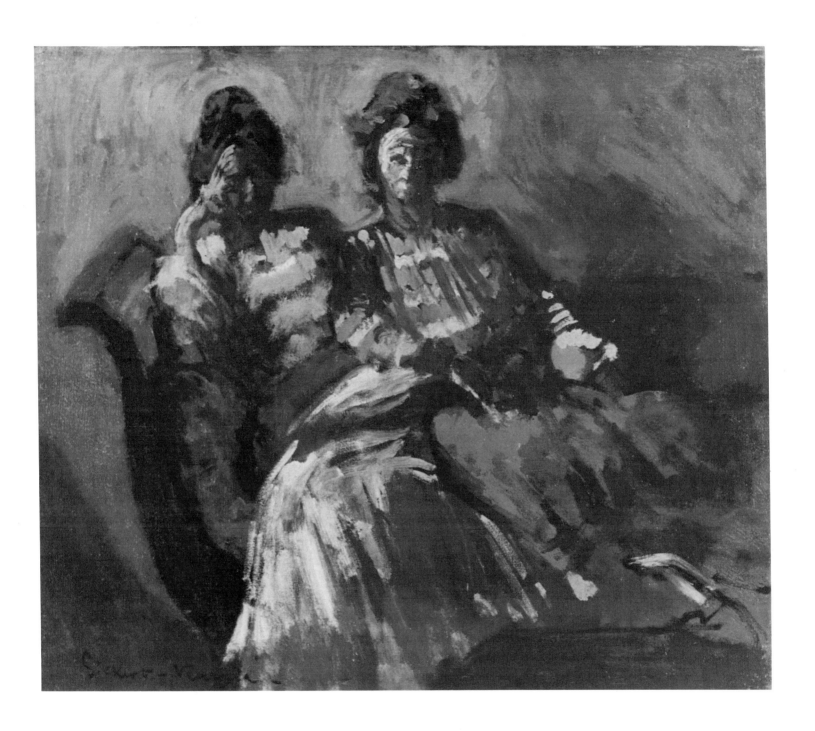

22. Walter Sickert. *Le Tose.* 1903–4. Oil on canvas, 45 × 52.7 cm. (17¾ × 20¾ in.) London, Tate Gallery

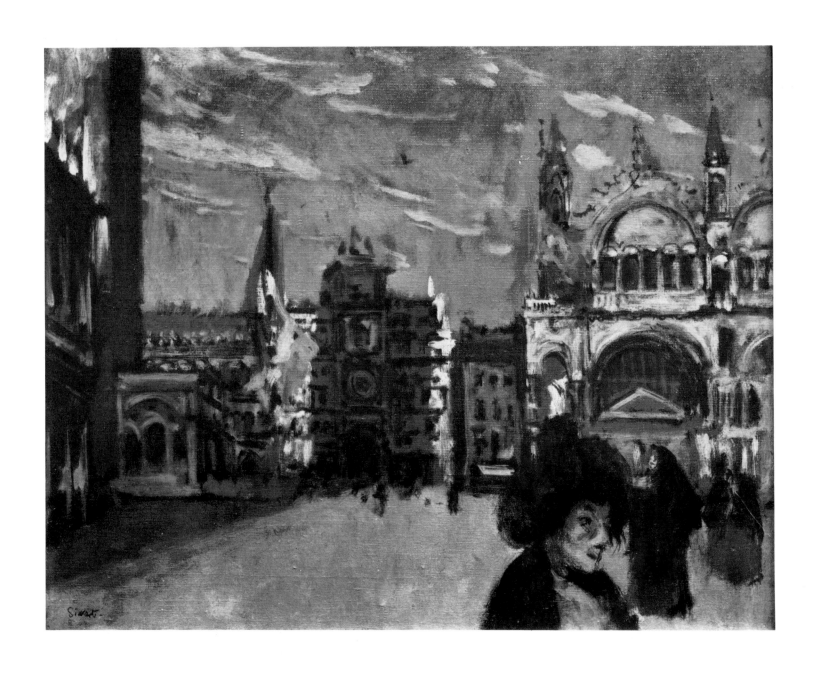

23. Walter Sickert. *St Mark's Square, Venice.* c.1906. Oil on canvas, 40.7 × 50.8 cm. (16 × 20 in.) Newcastle-upon-Tyne, Laing Art Gallery

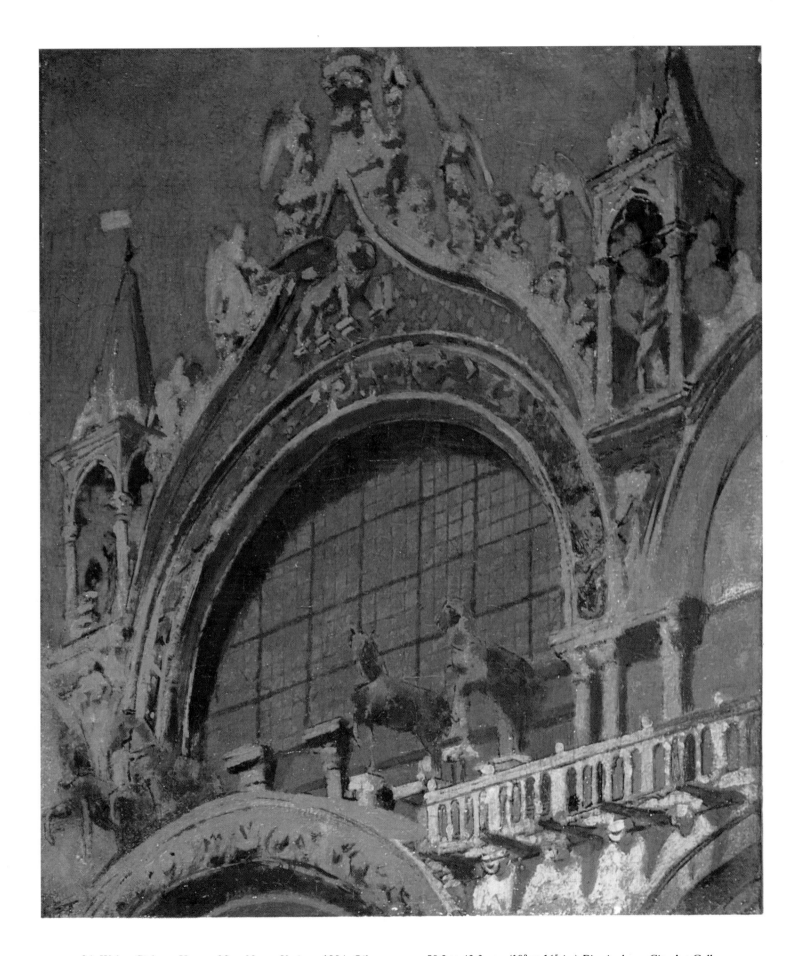

24. Walter Sickert. *Horses of San Marco, Venice*. c.1904. Oil on canvas, 50.2 × 42.3 cm. (19¾ × 16⅝ in.) Birmingham, City Art Gallery

methods of realization, produced some of the most fleeting and spontaneous images in British paintings of the figure.

It was this group of Venetian interiors that set Sickert on course towards the investigation of a theme that resulted in some of his greatest pictures. Although his colour range is still limited, with dusty purple, *terre verte* and cream seeping through the customary umbers, blacks and soiled ochres, his handling of paint becomes increasingly synoptic and assured. At all costs he avoids the definite statement, the unbroken contour, the features of a face which, if tallied too much to an expression of character, would upset the surface and decode his carefully achieved resonance of mood. Sickert most fully explores such willed prevarication in the later two-figure scenes of Camden Town; in Venice we see its beginnings.

By the summer of 1904 Sickert had returned to Dieppe. In June he held a large, mainly loan, exhibition at Bernheim-Jeune in Paris and was by then well known to a small circle of painters, critics and collectors, among them Paul Signac, J.-E. Blanche, Bonnard, André Gide and Daniel Halévy. He lived and worked at his house at Neuville, having moved from his mistress Mme Villain's home nearby. As a subject, Dieppe had begun to lose its appeal for him; his new interest in figures in interiors, particularly the nude on the bed, continued in Neuville until early 1905. It was during these months that the iron bedstead made its first appearance, a central feature of Sickert's imagery. Sometimes the curves of its head and end echo the figure sprawled along it, its two or three bars allowing nearly the whole figure to be seen as in, for example, *La Hollandaise* (Pl. 25) of two years later; at other times, the bars are almost cage-like, trapping the figure in the light reflected upwards from white sheets and coverlet. At the same time it is the most simple and utilitarian object, unembellished and unrefined. In the Dieppe pictures, the emphasis is on the bed and the nude, tightly organized round a diagonal and with little suggestion of the room (Pls. 28, 33). They are uncompromising works, eroticism barely held in check, yet not in the least ingratiating. The figure just survives amidst the hatched brushwork and coruscation of highlights.

Over the next four or five years, Sickert's intensive study of the nude, combined with his two-figure 'domestic' interiors, brought about a group of works which are highly personal and defiantly original in the context of contemporary English painting. They offended notions of propriety in a nation remarkably unable to draw distinctions between moral and aesthetic purpose. It was with such pictures that Sickert opposed the reigning gentility of much English art, still up to its neck in Chelsea and Newlyn, Pre-Raphaelite leftovers and breezy *plein-airisme*. In 1912 Sickert was to write, with characteristic irony, that he 'would not advise a British painter to depict a scene dealing with anyone lower in the social scale than, say, a University Extension lecturer and his fiancée, or to set his scene in a "Lokal", as they say in Germany, less genteel than a parlour, or to costume it otherwise than in "faultless evening dress".'

The frankness of Sickert's work has parallels with the new fiction of the late Victorian and Edwardian years, similarly originating in French naturalism of an earlier period. Passages in the novels of Bennett and Maugham reflect something of the atmosphere of Sickert's interiors; both writers, like Sickert, had spent long periods in France and were admirers of Degas, the Goncourts and Maupassant. But if Sickert is less warm than Bennett in his observations of lower middle-class life, he does not have Maugham's thorough contempt for humanity. But a consideration of Sickert's pursuit of his subject matter, with its implied criticism of much of the English art he saw around him, belongs later in this account, when Sickert had returned to England on a more permanent footing.

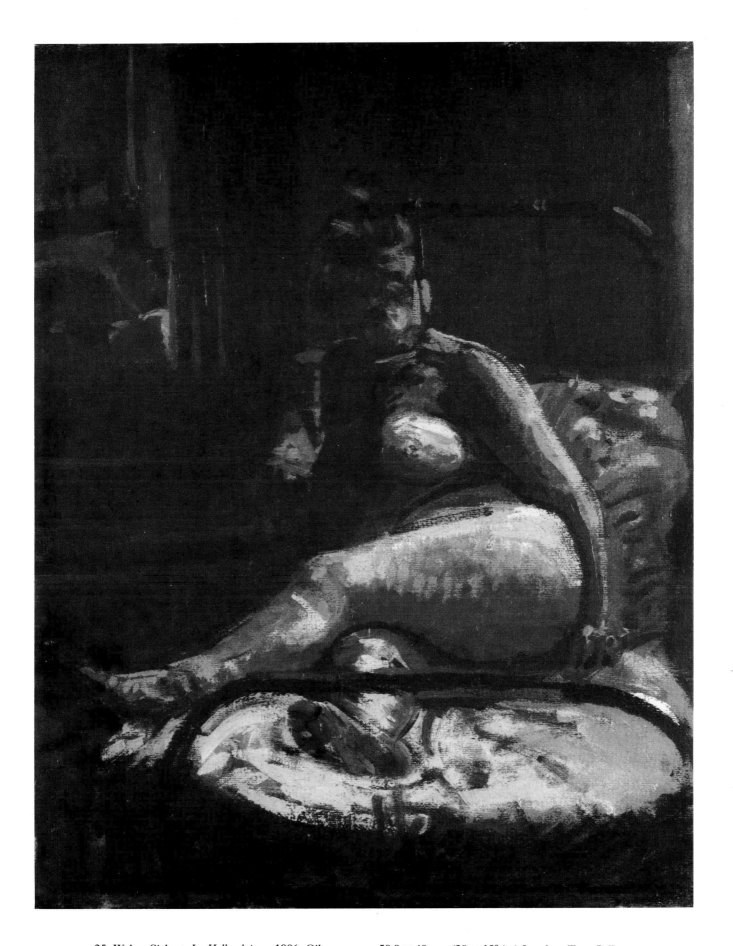

25. Walter Sickert. *La Hollandaise.* c.1906. Oil on canvas, 50.8 × 40 cm. (20 × 15¾ in.) London, Tate Gallery

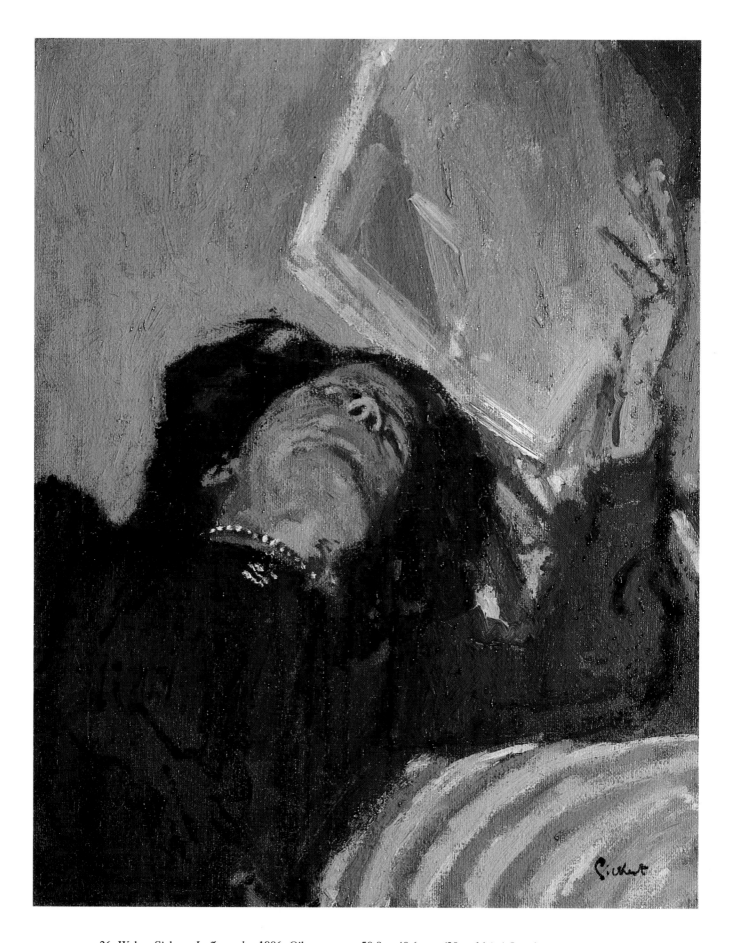

26. Walter Sickert. *Le Journal.* c.1906. Oil on canvas, 50.8 × 40.6 cm. (20 × 16 in.) London, private collection

THE RETURN TO LONDON

One of Sickert's firmest friends in England was the painter William Rothenstein, who had attended Sickert's short-lived Chelsea Life School, in 1893 (in which Roger Fry also enrolled). While Sickert was abroad, the two painters kept in touch, and in 1904 Rothenstein's younger brother Albert (afterwards Rutherston) visited Sickert at Neuville and introduced him to his friend Spencer Gore, a Slade School graduate, then aged twenty-six. They had much in common and soon became close friends, the relationship benefiting the art of both. It was this visit, perhaps more than anything, that persuaded Sickert to return to England. It was a move of incalculable importance in the history of modern British art, one of those cardinal moments by which its course has been plotted. In England Gore's friends included Wyndham Lewis and Harold Gilman. Gilman had recently exhibited for the first time with the New English Art Club, almost the only exhibiting society of any prominence that was at all welcoming to the work of younger artists.

Founded in 1886 as a riposte to the stultifying hegemony of the Royal Academy, the N.E.A.C. contained painters generally in agreement as to the merits of recent French art (both 'realist' and 'impressionist') and held twice-yearly exhibitions. Sickert had joined in 1888 and first showed in April that year, with two pictures, one of which was a painting of Gatti's Varieties. He had continued as a member, exhibiting mainly music hall paintings and portraits, until 1897 when he resigned. Thereafter he continued sporadically to show with the N.E.A.C. as a non-member, mainly in the hope of sales. By 1904 the generation of Gilman and Gore and their Slade contemporaries was beginning to exhibit but the Club was already showing signs of its age. Wilson Steer was no longer its brilliant star, and ossification of the jury was already responsible for the rejection of work by several younger aspirants. The Club was no longer performing its original function; the works of its members could not be called, as Sickert later commented, 'pages torn from the book of life'.

The problem the younger artists faced was that there was virtually nowhere else. Their work was by no means outrageous (unlike some of their French contemporaries); early Gilman is subdued, tonal, polite, with a sure eye for informal composition. Spencer Gore was increasingly influenced by Pissarro and possibly Sisley in his Normandy and Yorkshire landscapes and had already begun, on a small scale, to study performers and audience in the theatre. It was their very modesty, their scrupulous disregard of anything rhetorical, anecdotal or picturesque that ensured their position outside the lines of received taste. Sargent and Lavery, Orpen and John were the acclaimed 'modern' painters in a country only dimly aware of what had been happening in France and still in thrall to the tenets of Barbizon and the Hague School in landscape and genre painting. But there were signs of awakening, of cautious interest in the work of the young, and dissatisfaction with the elderly. In 1905, for example, Vanessa Stephen began the Friday Club for meetings

and exhibitions in order to recreate something of the lively studio atmosphere she had encountered on a visit to Paris the year before. It attracted young painters such as Henry Lamb and Derwent Lees. Rutherston's and Gore's talk of a new spirit among their contemporaries was by no means unfounded.

Thus, when Sickert felt sure enough of making London his headquarters once more, he was welcomed into a circle of artists who, for the most part, were intolerant of the Royal Academy, impatient with the N.E.A.C., not prepared to live by portraiture, pro-French and in need of exemplary leadership. Sickert was eager to assume the role. As he wrote to a potential disciple in 1907, '. . . I particularly believe that I am sent from heaven to finish all your educations!!' adding, significantly, 'And, by ricochet, to receive a certain amount of instruction from the younger generation.' Within two or three years Sickert's position as leader, advocate, animator and influence was paramount and secure. Although he did not turn his back on France (he went each year to Dieppe and continued to exhibit in Paris), his centre of operations from then on was London.

To this end and with characteristic extravagance, Sickert took three studios. One was at 8 Fitzroy Street, another a little further away at 76 Charlotte Street (in Constable's old house) and a third, a room at 6 Mornington Crescent (where Spencer Gore was established at number 31). Sickert here resumed his paintings of the London music hall, this time favouring the Middlesex (or 'Old Mo') in Drury Lane. And to this same period—pre-summer 1906—belong some of his most assured, dark and uncompromising nudes in interiors. There is *La Hollandaise* (Pl. 25), gleaming, almost simian in a raking light which defines one creamy breast and thrusts the other in black silhouette; the soles of her feet are carefully modelled, her left leg, weighty but alert; her face is almost featureless yet full of character. It is Sickert at his most sinister, fusing resignation and expectancy through the taut counterpoint of his design. The title most probably comes from Sickert's reading of Balzac, whom he admired, for 'la belle Hollandaise' is the name given to the prostitute Sara Gobseck in his 1830 *Gobseck*. It was also the name of George Moore's demimondaine and seducer in Paris, an incident Moore is bound to have recounted to Sickert. In *Le Lit de Cuivre* (Pl. 28), of which there are two versions, the paint is more darting and various; the model emerges from the bedclothes for one arrested moment before dissolution sets in and the colour surrenders to an airless monochrome. At the music hall in *Noctes Ambrosianae* (Pl. 32), the faces, hands and feet of the boys in the gallery become peach, vermilion and pale yellow highlights against the contrived black of the theatre wall; the railings and repeated plaster decorations contain the scattered figures in the way the metal bedsteads confine the malleable bedroom nudes.

Such works exemplify Sickert's famous words, written in 1910, that 'the real subject of a picture or a drawing is the plastic facts it succeeds in expressing, and all the world of pathos, of poetry, of sentiment that it succeeds in conveying, is conveyed by means of the plastic facts expressed, by the suggestion of the three dimensions of space, the suggestion of weight, the prelude or the refrain of movement, the promise of movement to come, or the echo of movement past.' Increasingly, Sickert's models appear to be taking part in some unspecified narrative and the unfocused yet deliberate strokes of quickly applied paint emphasize the flexibility of his interpretation. In a hotel room in Paris in late 1906 (the accommodating Hotel du Quai Voltaire), he worked on a series of paintings of women washing, dressing and undressing (Pl. 29). They are perhaps the nearest he comes to the same subjects treated by Degas and have affinities with Bonnard, alongside whom Sickert showed in that year's Salon d'Automne. Their restraint, elegance and quiet intimacy are at variance with such recent London images as *La Hollandaise* and with the other series of works which occupied Sickert in Paris, the French music hall. In several of these, Sickert's colour has some startling moments and the impulsive modelling of heads in the audience is close to caricature (as in *Le Théâtre de Montmartre* in the Keynes Collection, Cambridge). *La Gaieté Rochechouart* (Pl. 27), with its brilliant combination of

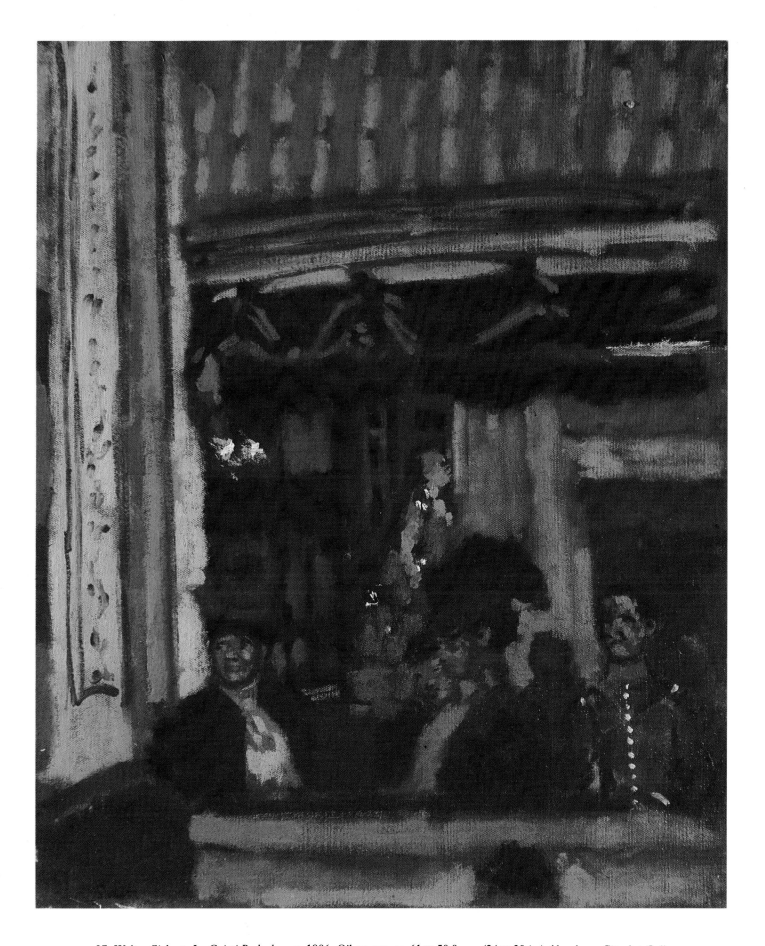

27. Walter Sickert. *La Gaieté Rochechouart.* 1906. Oil on canvas, 61 × 50.8 cm. (24 × 20 in.) Aberdeen, City Art Gallery

28. Walter Sickert. *Le Lit de Cuivre.* c.1906. Oil on canvas, 39.4 × 49.5 cm. (15½ × 19½ in.)
Exeter, Royal Albert Memorial Museum and Art Gallery

patrons and artiste (in the mirror at the back of the box), has a wit and suavity far removed from the spectral visions of the Old Bedford or the Middlesex. Such varieties in handling, mood and composition reflect Sickert's continual search for an ideal method of painting as much as the influences that run through his work at this time.

With Sickert's definite return to London in 1907, this search intensified, and he entered a phase of astonishing productivity. It saw, on his own admission, a conscious effort to 'recast my painting entirely', assimilating the influence of Lucien Pissarro and Gore. Sickert and Gore sometimes shared the same model in Mornington Crescent and occasionally drew side by side in the music hall. It is often said that Sickert induced Gore to make the theatre his subject matter. This is untrue; it had been one of his subjects for several years, but Sickert's example produced more unusual compositions in Gore's work, in which sections of audience and stage are integrated from a high vantage point. Gore retained his amused and almost childlike love of brilliant spectacle, as seen in his Alhambra paintings. He is more blithe and self-effacing, and when he observes an artiste on stage his observations are kindly. J. Wood Palmer neatly suggested the contrast between the temperaments of the two painters. For Gore the artiste is 'still a lady, just temporarily in ludicrous circumstances. To Sickert she would have been a woman and he would have known when she attempted a top note that her stays hurt and that she was longing for a pint.' Gore's theatres are filled with light and colour; we hold our breath as the turn commences; Sickert moves among shifting, gleaming surfaces. But when he begins, under Gore's influence, to colour what had been opaque olive and umber shadows, he flares sometimes into dotted and lightly hatched primaries, into orange, violet and viridian, which form some of the most seductive passages of colour in English painting.

Sickert was wary perhaps of this new-found freedom and his works alternate between a higher key and the more customary darker tones. But even these are applied in a more broken, even cursory manner so that density is relieved. There is a parallel evolution in Sickert's drawings and in etching, a medium to which he returned with vigour to produce compelling theatre scenes with an increased variety in his treatment of the plate. Running alongside these studio activities were his teaching, writing and the growing demands of his leadership of the young artists who formed the Fitzroy Street Group in 1908. That year marked too the emergence of Sickert's definitive relationship with Camden Town, both as district and psychological terrain.

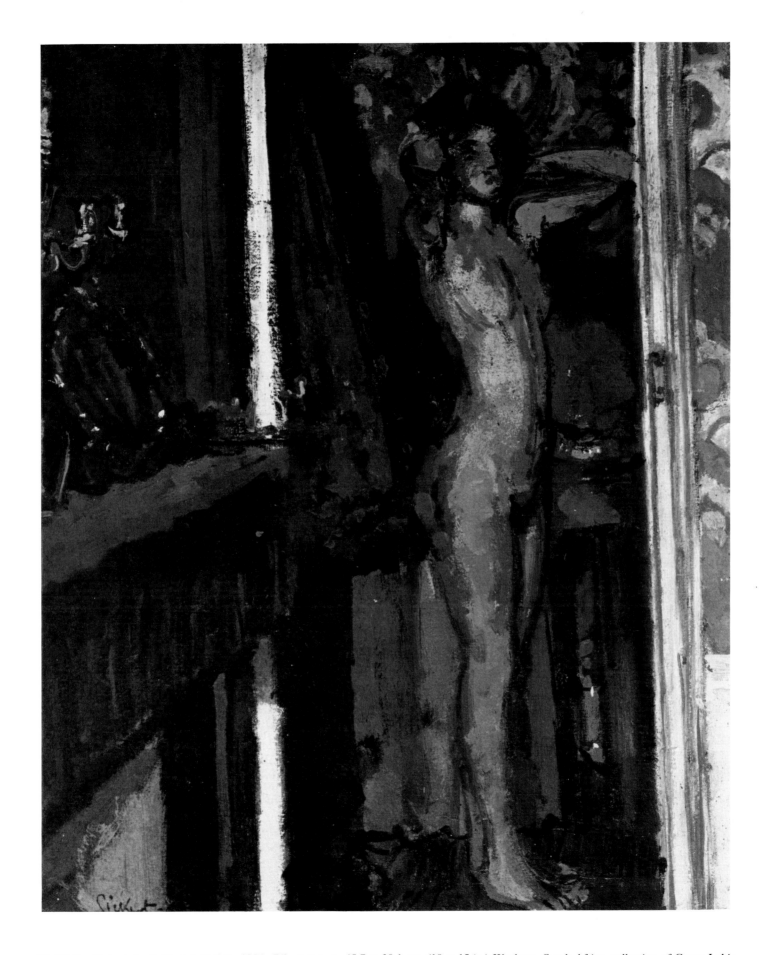

29. Walter Sickert. *Le Cabinet de Toilette.* 1906. Oil on canvas, 45.7 × 38.1 cm. (18 × 15 in.) Wynberg, South Africa, collection of Count Labia

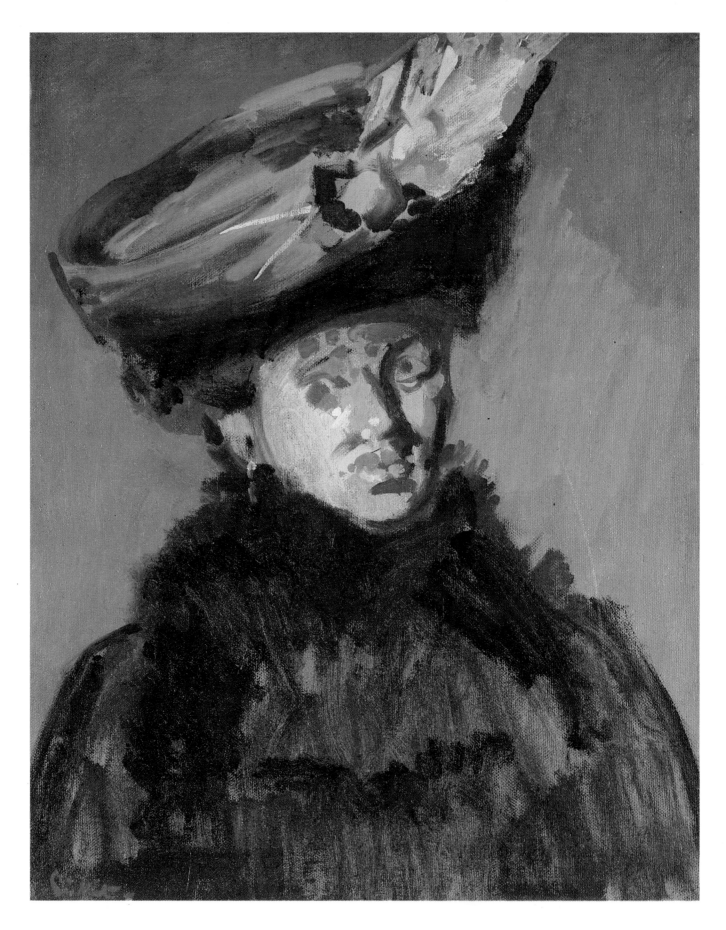

30. Walter Sickert. *Woman in a Green Hat.* 1906. Oil on canvas, 59 × 49 cm. (23¼ × 19¼ in.) Private collection

The Master of Camden Town

Sickert was no stranger to this part of North London. He had haunted the Old Bedford music hall at the centre of Camden Town and had kept a studio in Robert Street, further south. Originally conceived as a service area for the grander houses skirting nearby Regent's Park, Camden Town, with its carefully planned streets, squares and markets, had undergone three debilitating operations in the nineteenth century. King's Cross, Euston and St Pancras stations had been constructed at its southern border. Railway lines and their attendant carriage sheds, goods yards and waste ground cut through the district, demolishing houses, lopping away gardens and lowering its social and physical condition to a seedy and distinctly unfashionable inner suburb. It was tailor-made for Sickert. The population was predominantly cockney and Irish; many of the three- or four-storey houses, with their undemonstrative façades and plunging basements hemmed by railings, had been divided into rented rooms and small businesses. It was not exactly slummy nor yet such a self-contained community as were certain areas of East London. But its tone was robust working-class, of pickles, stout and chops, full of pubs and eating houses, with the rebuilt Bedford up the High Street (the replacement for Sickert's Old Bedford, burnt down in 1898) and the Camden Theatre down near the underground station of Mornington Crescent. Spencer Gore has best captured its light, monotonous crescents and streets with their sooty back gardens where washing hangs and beauty is improvised. Sickert introduces us to the types of the district—to Chicken and Sally, Hubby and Marie and Mrs Barrett. Gore gives us their setting, more genteel than we might have envisaged, lovelier than we have been allowed to imagine. Sickert guides us indoors to reveal the sharps and flats of daily life.

Whatever lingering respectability the district may have had in the public's mind was dispelled in September 1907 by the sensational murder of a prostitute called Emily Dimmock, the 'Camden Town Murder' as it was called in the press. Sickert perpetuated this grisly affair in a large group of drawings and paintings. Although only one actually recreates the event, all are highly suggestive of emotional and impending physical conflict. Nothing quite prepares us in his previous work for the intensity of his depiction of the clothed male figure and the naked woman in the most celebrated version from the series *L'Affaire de Camden Town* (Pl. 37). The man is shown standing, arms folded in cold deliberation, his shadow on the wall and curtain; turning on the bed, his victim presses one foot against the bed-rail, an arm flung across her face in an ambiguous gesture. Sickert underlines her vulnerability by his frank portrayal of her open legs, the vertical and horizontal axes of the picture meeting at the dark patch of her pubic hair. Everything in this compact composition adds to the numbing sense of catastrophe; even the regular patterning of the wallpaper emphasizes the suffocating atmosphere of the room (almost certainly Sickert's studio at 247 Hampstead Road, the Wellington House Academy where Dickens had been a pupil). The other well-known painting which

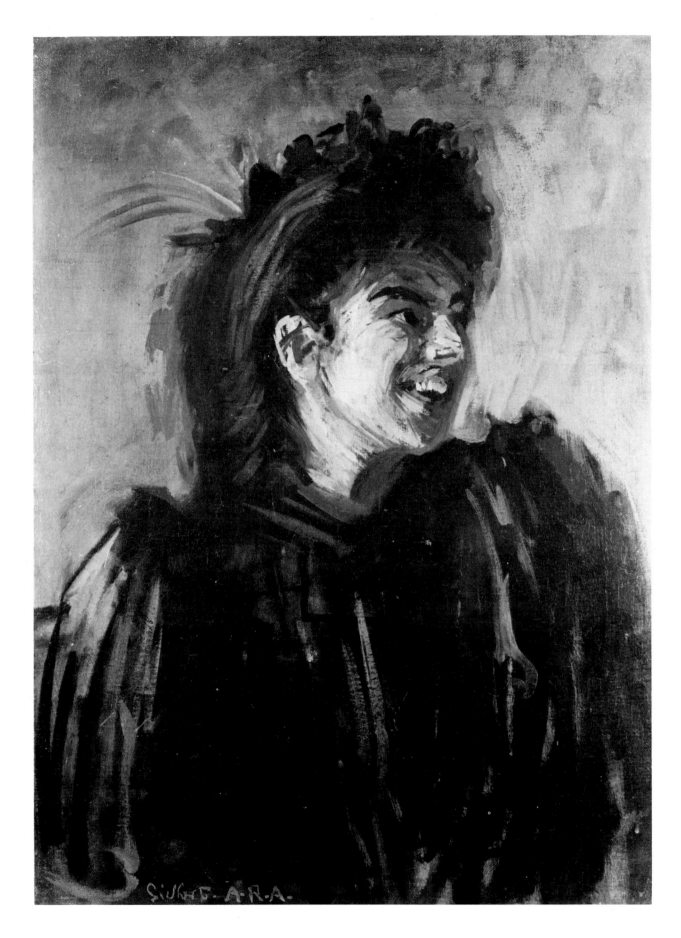

31. Walter Sickert. *The Blackbird of Paradise.* c.1906. Oil on canvas, 66.1 × 48.3 cm. (26 × 19 in.) Leeds, City Art Gallery

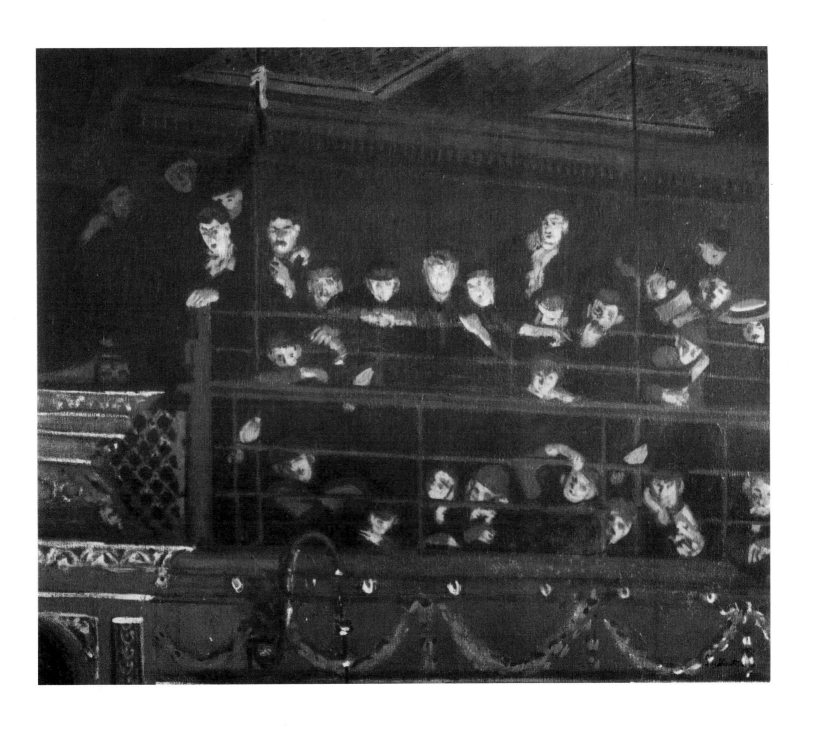

32. Walter Sickert. *Noctes Ambrosianae*. 1906. Oil on canvas, 63.5 × 76.2 cm. (25 × 30 in.) Nottingham, Castle Museum and Art Gallery

alludes to the murder is alternatively entitled *What Shall We Do for the Rent?* (Pl. 38). It seems more appropriate to the inert, despondent mood Sickert conveys, even though the woman's hand lightly touches the man's knee and her hair is curiously unruffled for an early morning talk on the financial situation. Once more, these enigmatic pictures raise the question of Sickert's notions of subject matter, of how far 'real life' might take him, of what was paintable and what was not, of how the final image was to be achieved.

In his early essay 'Modern Realism in Painting', already referred to, Sickert praises Millet for the manner in which the French artist trained his memory to work away from nature 'by a process of cumulative observation'. Incessant drawing brought about an accretion of daily observations in which the artist not only developed his sensibility but could make studies with a definite aim in mind—the final picture. Such drawing, Sickert wrote in 1912, should be carried out 'with the kind of avidity and success—shall we say?—that would be a man's who hunted a rabbit or speared a salmon when he felt the need of a dinner.' This was Sickert's lifelong teaching and, until the last decade of his life, his constant practice. Again, he wrote, 'it is only the artist whose sketching is informed by the necessity of making it a means to something further, who touches the highwater mark of excellence in the sketches themselves.' The English draughtsman for whom Sickert had the greatest admiration was Charles Keene; '. . . if we allow ourselves to ask who was the greatest English artist of the nineteenth century,' Sickert wrote, 'it would be difficult even to find a candidate to set against Charles Keene, a draughtsman on a, then, threepenny paper.' Sickert's debt to Keene's drawings is considerable, particularly Keene's humorous interiors with two figures which find correspondence with Sickert's Camden Town interiors. Even Sickert's titles have a strong whiff of Keene's own such as *A Clean Breast of It, The Irrepressible* and *Those Dreadful Boys*. Sickert, who had known Keene and acquired his work, would surely have endorsed Whistler's words that Keene was 'the greatest English artist since Hogarth'.

The Camden Town Murder paintings and the ensuing series of men and women in interiors were brought about by innumerable studies that gradually focused the final image. Several previous paintings as well as drawings were mined for information towards the evolving disposition of the figures in a particular setting. A nude seen from the back on a bed in Mornington Crescent finds herself the following year pressed against a menacing man in shirt-sleeves. A charwoman in a plumed hat is one year the subject of a drawing called *Patient Merit* and the next the hurt protagonist of *That Boy Will Be the Death of Me* (Pl. 49). A slight adjustment in the relation of two figures, a different fall of light, and the whole psychological potential of the picture changes. But how discreet Sickert is, how unrhetorical. There is none of that meretricious chiaroscuro of the 'subject' picture nor the piquant highlights of fashionable portraits. Sickert is, as André Gide remarked, morose. His light is veiled and deflected, glowing indirectly from a mirror or thrown up from the dusty surfaces of cheap polished furniture. It feels its way across a room leaving much unexplained, to reveal here an outline, there an accent, sometimes a sudden full illumination as pointer to an unexpected mood.

From now on people were at the centre of Sickert's conception of painting. The relation of the sexes is his ostensible subject; lassitude, boredom, resignation their perennial message. Occasionally a note of rebellion is sounded as in drawings such as *Back-Chat, The Argument* and *The Tiff*, but the scuffles are small beer. The scenes are often ambiguous in their intent, and the titles, added afterwards, can even be misleading (and were often changed from one exhibition to another). Invariably they echo a popular catch phrase, such as 'that boy will be the death of me' or a tune such as 'Lou! Lou! I love you'. In sentiment they are close to situations found in music hall songs, miserable rather than tragic, the men laconic and the women stoical; money is often at the bottom of the matter, as it was in the

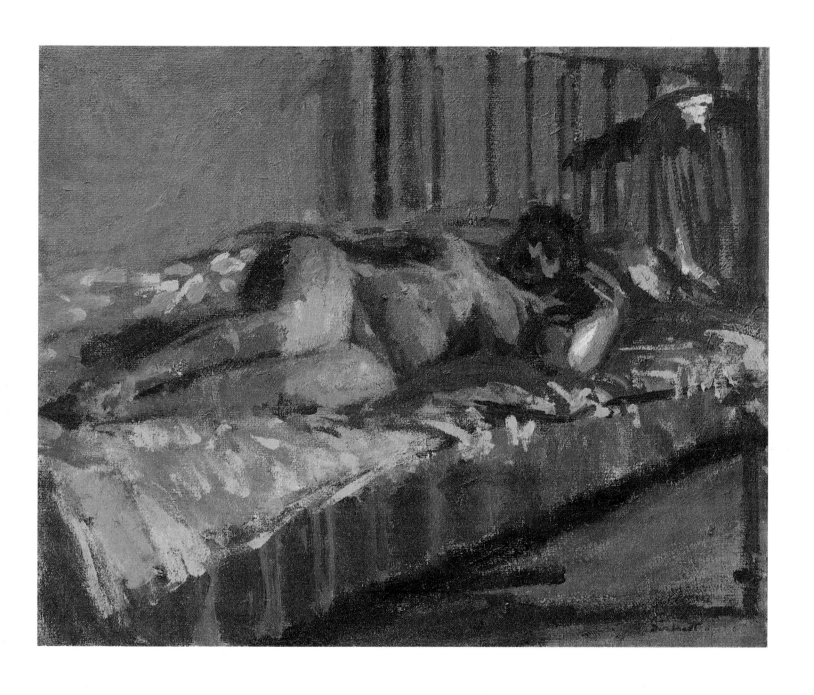

33. Walter Sickert. *Nude Reclining on a Bed.* c.1904–5. Oil on canvas, 44.5 × 54.6 cm. (17½ × 21½ in.) Anthony d'Offay Gallery, London

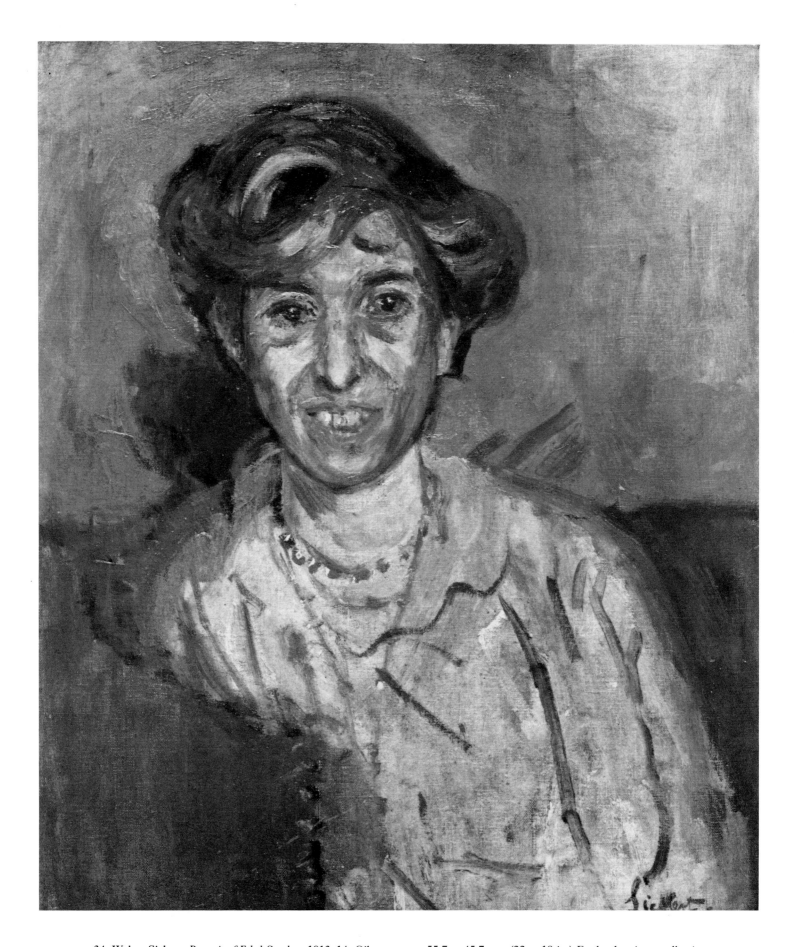

34. Walter Sickert. *Portrait of Ethel Sands.* c.1913–14. Oil on canvas, 55.7 × 45.7 cm. (22 × 18 in.) England, private collection

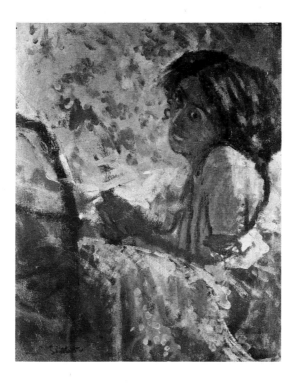

35. Walter Sickert. *Oeillade*. c.1911. Oil on canvas, 38.4 × 30.5 cm. (15¼ × 12 in.) Cambridge, Fitzwilliam Museum

halls, enshrined in Tom Costello's famous 'At Trinity church I met my doom' with its fatalistic lines 'Now we live in a top back room/Up to my eyes in debt for renty.'

It is difficult to gauge Sickert's own view of the lives he was portraying. They do not come out of the life he himself led in the way, for example, that Mark Gertler's early East End Jewish scenes or Vuillard's domestic interiors were part of their surroundings and experience. Sickert, like Degas, preferred to dissociate himself from his subject matter. (It is only in his later years that we find wry depictions of his own domestic life.) He invariably kept home and work place quite separate, and, though obviously attached to some of his many studios, change was essential. Curiously, he was a stickler for propriety and, as has been suggested, was something of a snob. Like many artists, he was deeply conservative on social and political questions (with the occasional anarchistic streak), upholding the status quo. His profound dislike of socialism was tempered by a carefully checked generosity and brisk sentiment of heart. His choice of subject matter in the Camden Town period was closer to Baudelairean precepts of the painting of contemporary life than to any firm convictions about the shabby lot of the working class. The exaggerated respect afforded to him by some recent writers for his depictions of 'real life' distorts the very springs of Sickert's art and his wayward views on society; it adds an irrelevant didacticism to his work which finds no source in what we know of Sickert's attitudes to the social fabric.

That certain types attracted him it is true, but they were chosen for a variety of reasons, not least perhaps their inferior social position (something we would not ascribe, for example, to Gilman's or Gore's North London portraits) and the frank availability of their lives. He could show his models in all the drab tedium of their existence without recourse to flattery. No social compunction compelled him to disguise Chicken's terrible teeth, for example,

51

and so we have a masterpiece (Pl. 50) in line with Hogarth's *Shrimp Girl*. Sickert seems to have been impervious to conventional notions of beauty or allure; he liked something seasoned and many of his favourite models were distinctly *jolie-laide*. He preferred the worn good looks of his charwoman Mrs Barrett or the nondescript comeliness of Marie, and his most frequent male model was a middle-aged ex-con and feckless old school associate known simply as Hubby.

There were, during this period, several portraits but none, as far as we know, was commissioned. Nearly all are of women (the exceptions are Jacques-Emile Blanche and Harold Gilman) and range widely in mood and character—from the self-conscious smile of Ethel Sands (Pl. 34) to the uninhibited Halsian grin of Chicken, from the mysterious Mrs Barrett (Pl. 44) to the neurosthenic presence of *Woman in a Green Hat* (Pl. 30). Sickert had emphatically abandoned commissioned portraiture in the late 1890s and it became increasingly the butt of his contemptuous humour in the Camden Town period.

He had urged his colleague Wilson Steer towards figures in interiors and away from 'well-chosen young persons'; painters should avoid the inducements of society portraiture at all costs, the trap of 'fashionable flic-flac', the 'bravura of the *décolleté*' as seen in Boldini and Helleu, Blanche and Sargent. While Sargent's gifts are admitted, Sickert reserves his scorn for the subservient criticism his work aroused in 'a decade of unbroken adulation'. Sickert's views on Sargent were echoed by Roger Fry in one of the rare instances of their agreement in print. But where Fry might have been dismissive, Sickert could be generous to the Royal Academy portrait; its sound craftsmanship made its appeal beyond distinctions of taste and fashion, of what was 'in' and 'out'. Respect for tradition, the ability to situate a figure in space, the able drawing of a head or the 'gracious elaboration' of a serious academic composition—all these drew Sickert's approval. He reserved his contempt for effects gained regardless of truth, for painting directed by social concerns, for the flashy materialism of the Salon nude or Burlington House mythologies. They were outside the grand European tradition of which he saw himself as an inheritor, through Degas and Whistler back to Courbet, Millet and Corot. On all occasions Sickert stressed the importance for students of study of the central highway of the European tradition, particularly in a period of rapid change and the proliferation of approaches made available in the pre-First World War period. 'How barbarous you would seem if you were unable to bestow your admiration and affection on a fascinating child in the nursery without at once finding yourselves compelled to rush downstairs and cut its mother's throat, and stifle its grandmother! These ladies may still have their uses.'

These words of 1910 were soon to apply to Sickert's own position. No sooner had he surrounded himself with a group of young painters who looked to his leadership and admired his achievement, than the rug was whipped from under his feet by his usurping friend Roger Fry and the pervasive influence, even within his own camp, of Cézanne, Van Gogh, and Matisse. How could he advance the claims of Courbet, Millet and Degas, let alone Keene, Poynter or Orchardson, in the face of the radical excitement that Post-Impressionism offered to the young artist of the period?

The two Post-Impressionist exhibitions at the Grafton Galleries in London in 1910 and 1912 left their mark on Sickert's younger colleagues in ways that Sickert was unable to ignore. Their independence was a direct challenge to much that Sickert stood for and his position as a leader of the modern movement in England came under serious reconsideration. His defence was curious. On the one hand he maintained that it was really rather late in the day to become excited by Van Gogh, Gauguin and Cézanne (and certainly Sickert had been familiar with these artists' work since the days of his close contact with Paris); on the other hand, he felt that their influence was

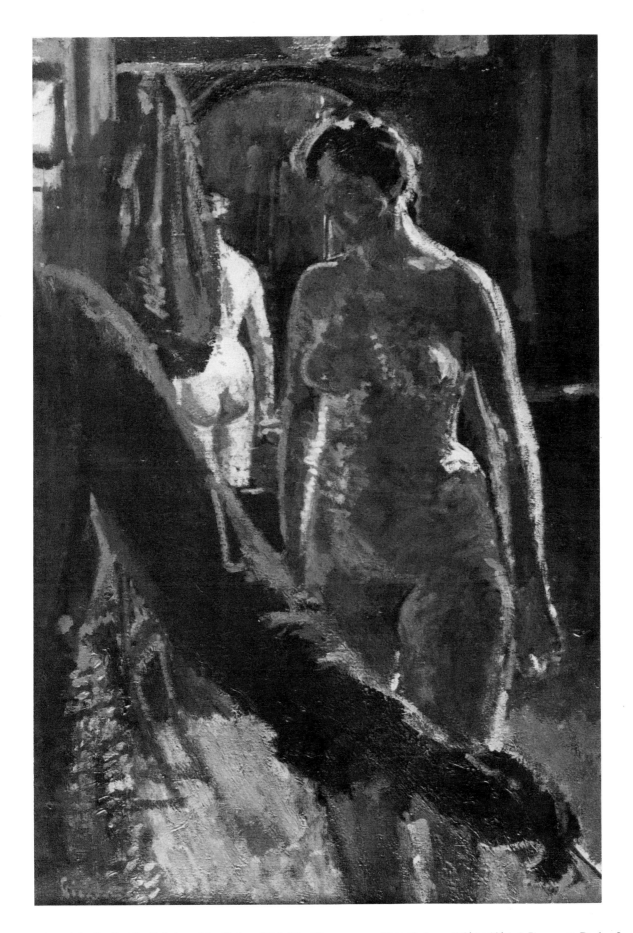

36. Walter Sickert. *The Studio. The Painting of the Nude.* c.1911–12. Oil on canvas, 75 × 49.5 cm. (29½ × 19½ in.) Browse & Darby, London

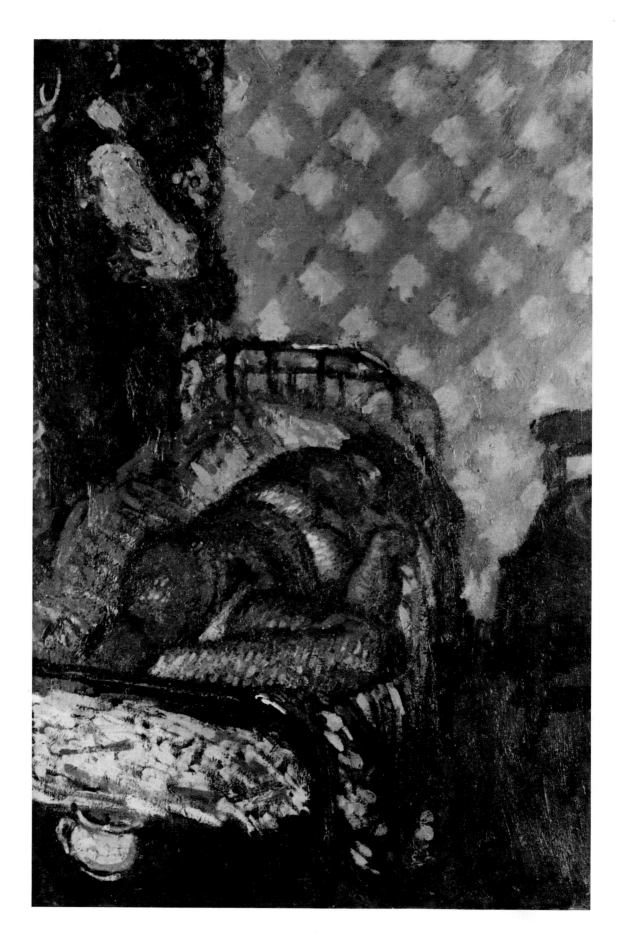

37. Walter Sickert. *L'Affaire de Camden Town*. 1909. Oil on canvas, 61 × 40.6 cm. (24 × 16 in.) Private collection

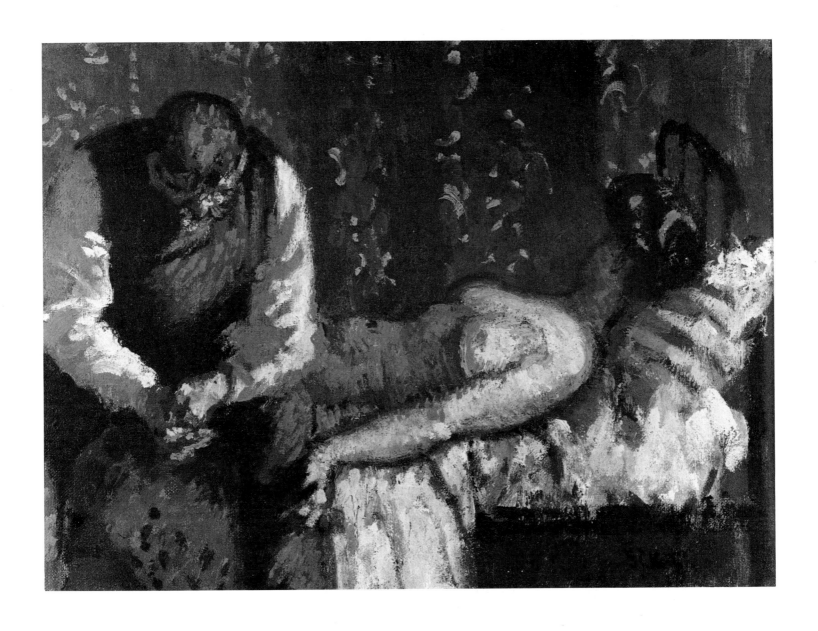

38. Walter Sickert. *The Camden Town Murder* or *What Shall We Do for the Rent?* c.1908. Oil on canvas, 25.6 × 35.5 cm. ($10\frac{1}{16}$ × 14 in.)
New Haven, Yale Center for British Art, Paul Mellon Fund

disproportionate to their achievement and that the great tradition lay with the followers of Degas and Pissarro. The young were being misled by critics and advocates such as Roger Fry, Clive Bell, Frank Rutter and others. Sickert thus found himself both radical and reactionary. His distaste for the early work of Matisse and Picasso drove him to an overstatement of his case against the older Post-Impressionists, particularly Cézanne, and forced him to express views not really commensurate with his actual feelings. In fact he writes more in praise of Cézanne than is usually admitted, but the unrelieved advocacy of the French painter, by Clive Bell in particular, occasioned broadsides from him which are difficult to forget.

At the same time it must be stressed that Sickert's tastes were already formed by 1910 (when he was fifty years old) and that his own painting was still undergoing transformations through the study of an older Impressionist practice as seen in Camille and Lucien Pissarro and the earlier Gore. He was nearer in sympathy to Bonnard and Vuillard (his juniors by seven and eight years respectively), both indebted, like Sickert, to Degas. The suggested influence of Bonnard is difficult to estimate and what at first appear to be similarities are in fact derivations from Degas. But Bonnard's paintings of intimate daily life would have reinforced Sickert's own direction. Pertinent examples which Sickert might well have known include *L'Homme et la Femme* and *La Sieste*, both of 1900, and several works showing a female nude reflected in a bedroom or bathroom mirror of 1908–9. But the temperaments of the two artists were so different that the relationship is more one of confirmation than of influence. (It is worthwhile noting that Bonnard purchased a painting by Sickert in Paris in 1909; Luce, Signac, Blanche and, later, Segonzac, were other French painters who owned Sickert's work.)

If, for younger painters, Sickert was beginning to represent an already superseded aesthetic, elsewhere he could still fire controversy. 'I cannot believe,' Sir William Richmond told the art critic Robert Ross, 'you wrote that odious eulogy of such [an] incompetent and debased expression of debauchery.' The elderly Royal Academician was referring to Sickert's 1911 exhibition at the Carfax Gallery of forty-nine drawings, mainly of domestic subjects. 'From an artistic point of view the drawings are worthless,' Richmond continued. 'From others, they are abominable. Ugly Dirt is odious. Sexualism in Art can only be redeemed by grand treatment. This is worse than Slum Art, worse than Prostitution, because it is done by a man who should know better' Richmond had obviously had an apoplectic week for he had previously visited and been horrified by *Manet and the Post-Impressionists* at the Grafton Galleries; but he felt that Sickert was 'worse' than anything there. More surprising was the reaction of Sickert's New English Art Club colleague Fred Brown, professor of painting at the Slade School, who felt obliged to sever their friendship on account of the 'sordid nature' of Sickert's pictures. Certainly by the side of such paintings, the apples and napkins, studio nudes, the guitars and *petits verres* of the French artists were almost indecently chaste. Sickert appeared far more daring in terms of subject, though much of the suggestiveness of his work can be attributed to the generally low key of his colour and the lack of definition in his figures, rather than to any precision of narrative. His titles underlined his ambiguity of theme, though in some cases they were pointedly appropriate.

The French title, for example, of Sickert's best-known subject, *Ennui*, has exactly the resonance of the personal predicament conveyed by Hubby and Marie. Sickert has here monumentalized not simply boredom but their apathetic attitude to life in general as much as to each other. The work is in several versions dating from 1914 to about 1916, and there are numerous studies of the composition (Pl. 45) and its details. The smooth propriety of the paint (save for the glass and matchbox) and the slightly unpleasant colour of the Tate Gallery version contrasts with the animated, decorative surfaces of the one in Oxford (Pl. 46). Where the spatial scheme of the Tate *Ennui* is perhaps more carefully articulated, the Oxford picture gains in mood through contrast. The more uptilted position

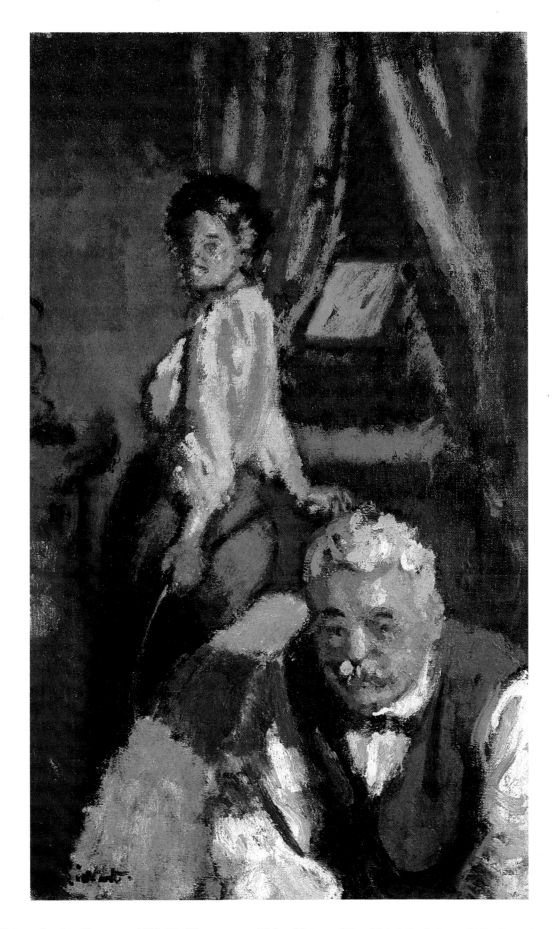

39. Walter Sickert. *Sunday Afternoon.* c.1912–13. Oil on canvas, 50.8 × 30.6 cm. (20 × 12 in.) Fredericton, N.B., Beaverbrook Art Gallery

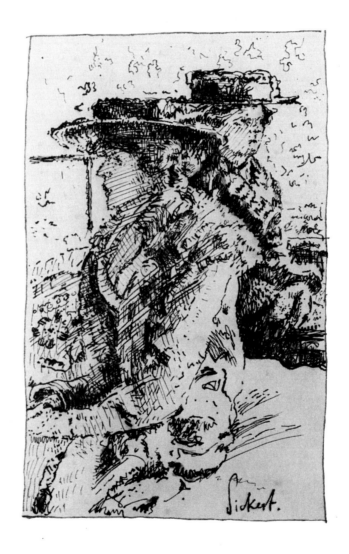

40. Walter Sickert. *Lou! Lou! I love you.* 1911. Ink, 12.6 × 8.3 cm. (5 × 3¼ in.) London, private collection

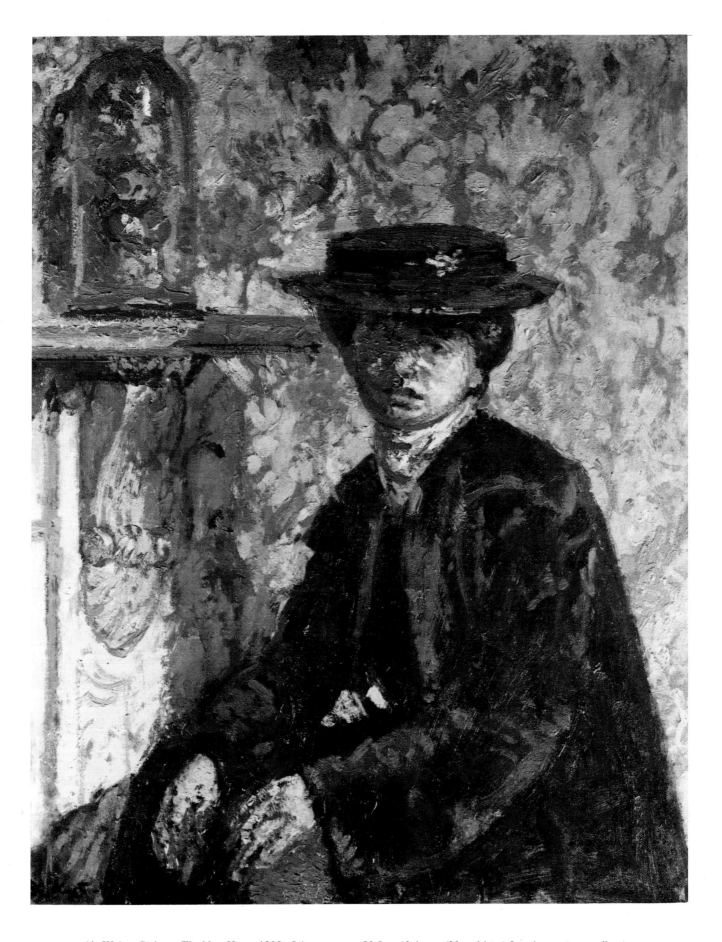

41. Walter Sickert. *The New Home.* 1908. Oil on canvas, 50.8 × 40.6 cm. (20 × 16 in.) London, private collection

of the man's head, as he draws on his cigar, accentuates the distant look in his eyes contemplating, as Virginia Woolf famously suggested, 'the intolerable wastes of desolation in front of him'. The Tate version is a little dull and possibly too large to maintain the psychological tension throughout. Sickert worked best at this period on a relatively small scale; it was not until the late 1920s that he tackled large canvases as a matter of course and with confidence. By then he had almost dispensed with working from drawings, thus avoiding some of the niceties of detail that were retained from paper to canvas.

When Sickert embarked on *Ennui* in 1914, he was still a central, if contentious figure in the progressive art world of London. He wrote copiously for *The New Age* and edited a series of 'Modern Drawings', published in the same paper, by himself and his followers. His work was widely seen and he was in touch with art schools, exhibiting societies, dealers and patrons. At the same time a note of dissatisfaction at the turn of events can be detected in his writings and actions. He quarrelled in a grimly humorous vein with his Camden Town Group associates Gilman and Ginner; 'The Thickest Painters in London' (*The New Age*, 18 June 1914) contains his verdict on their newly conceived Neo-Realist doctrine. He viewed with sharp incomprehension the ascendancy of such figures as Lewis, Epstein and Gaudier-Brzeska; his feigned horror at the explicit nudity in their work led in 1914 to his resignation from the recently formed London Group which had absorbed the Camden Towners. (Some years later, however, he defended Epstein by resigning from the Royal Academy, and wrote in praise of Lewis's drawings.) How seriously all this is to be taken is difficult to judge. Sickert enjoyed controversy; the expression of his current moods and *bêtes noires*, and a certain personal opportunism were integral to his character. In articles and letters to the press he showed himself a master of the courteous snub, the superbly disobliging remark, in witty and dizzying commentaries on Millais and Whistler, on the Contemporary Art Society, on Berenson and Fry, on the history of the Derby and the case of the Tichborne Claimant (which for years obsessed him). But he could be deadly serious too, and when his close friend Spencer Gore died in March 1914, at the age of thirty-five, Sickert wrote an obituary 'A Perfect Modern' in *The New Age* which is one of the most moving tributes written by one painter to another.

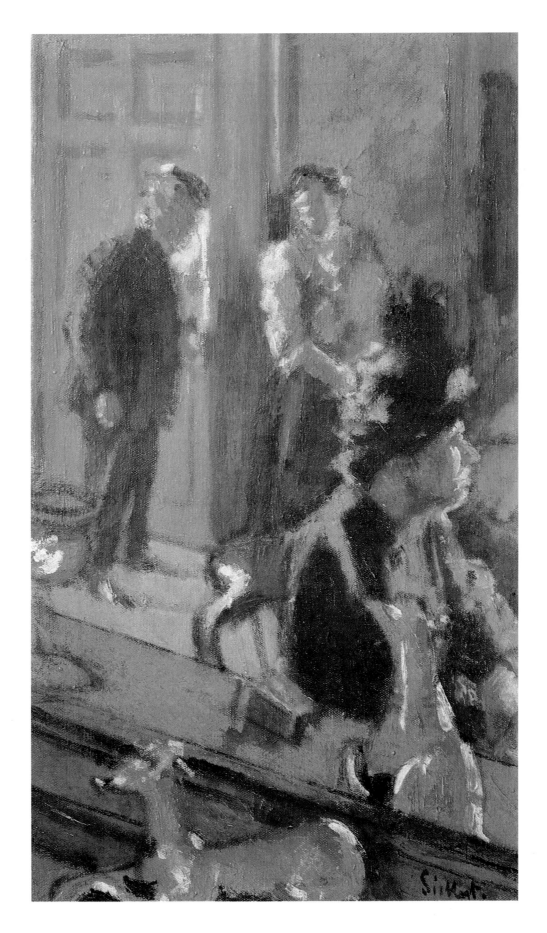

42. Walter Sickert. *A Few Words. Off to the Pub.* c.1912. Oil on canvas, 50.8 × 30.5 cm. (20 × 12 in.) London, private collection

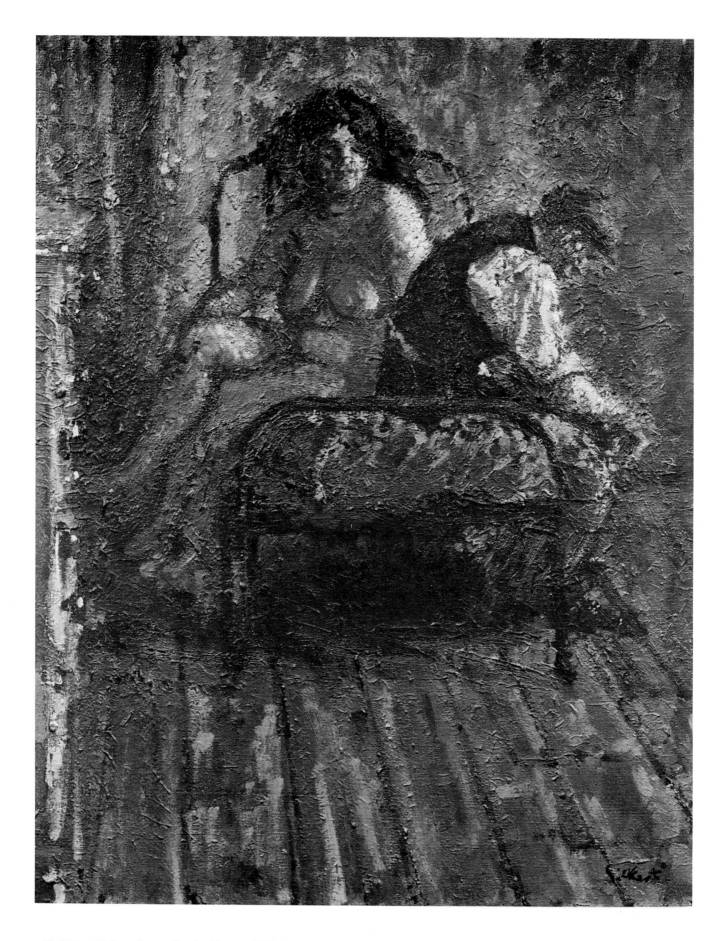

43. Walter Sickert. *Dawn, Camden Town.* c.1909. Oil on canvas, 50.2 × 40.6 cm. (19¾ × 16 in.) The Earl and Countess of Harewood

44. Walter Sickert. *Mrs Barrett. Blackmail.* c.1906. Pastel on board, 66 × 54 cm. (26 × 21¼ in.) Ottawa, National Gallery of Canada

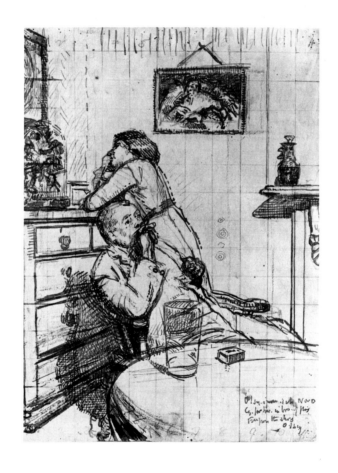

45. Walter Sickert. *Study for 'Ennui'*. c.1914. Chalk and ink, 37.5 × 26.7 cm. (14¾ × 10⅜ in.) Oxford, Ashmolean Museum

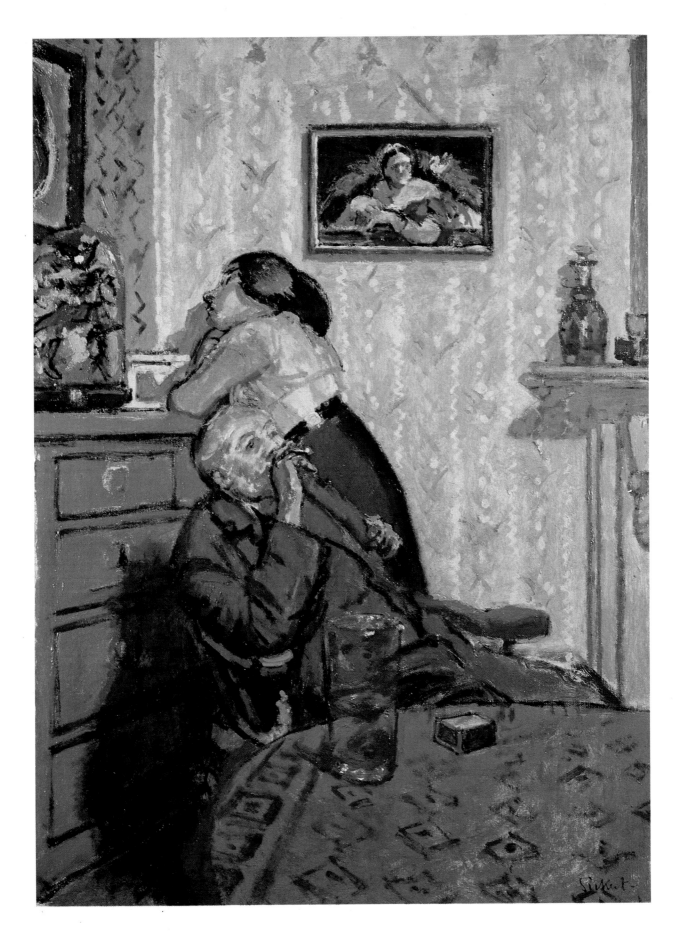

46. Walter Sickert. *Ennui*. c.1914. Oil on canvas, 76.2 × 55.9 cm. (30 × 22 in.) Oxford, Ashmolean Museum

47. Walter Sickert. *My Awful Dad.* c.1912. Chalk, 37.8 × 27.4 cm. (14⅞ × 10¾ in.) Oxford, Ashmolean Museum

— FOUR —

TOWN, KING AND COUNTRY

When war was declared in August 1914, Sickert was with his second wife, Christine Angus, at their house at Envermeu near Dieppe. He was naturally reluctant to abandon a group of new motifs he had found: the blue skies and bright flowerbeds of the rue Aguado, the clients at their tables outside the Café Suisse. But back they came on the Newhaven boat to resume once more life in Camden Town and Fitzroy Street. The following four years in England saw some remarkable changes in Sickert's work even if the period is scarcely notable for any series as intense and rewarding as the domestic interiors of the previous decade.

What impression did Sickert make on people at this time? As his fame in England increased (and dwindled correspondingly abroad), friends and acquaintances began to observe him, leaving invaluable accounts of his sometimes astonishing appearance, prolix conversation and growing eccentricity. There is a danger in being carried away by the Sickert 'legend', helped by numerous witnesses who promoted such a view even when Sickert was alive. Over the years his extravagant personality has been recorded by writers and artists of several generations. All establish the magnetism of his presence and his wide-ranging talk which combined high seriousness with a comic relish for every aspect of life; songs from the music hall, chunks of Shakespeare and slangy or literary allusions in several languages poured forth at any opportunity. 'I always used to believe,' wrote Duncan Grant, 'that Cocteau's was the most brilliant conversation I ever heard but I'm now inclined to think that Sickert's was unbeatable when he was on form. But being ignorant of German and the Venetian dialect, I daresay I missed a good deal' (in a letter to the author, 14 April 1971). A younger generation was spellbound. During the war, his breakfasts and tea parties in Fitzroy Street would be attended by his students, by soldiers on leave, denizens of the neighbourhood, by younger painters such as the Chilean Alvaro Guevara and Nina Hamnett. For both these artists Sickert wrote extravagantly enthusiastic reviews of their first exhibitions (in 1916 and 1918 respectively). His article on Nina Hamnett is typical: jokes, innuendo, prompt wisdom on the contour in drawing; a tempered attack on Cézanne braced to an admiration for Nina Hamnett's teachers, Cope and Nicol; and a superb aside on Roger Fry, 'the neo-palaeo-potter' of the Omega Workshops (where Hamnett and Guevara worked and exhibited). 'How many of the younger vessels of the rising generation will be found to bear, on careful inspection . . . *Omega* profoundly stamped beneath them!' Sickert painted Nina Hamnett and her husband Roald Kristian in *The Little Tea Party* (Tate Gallery), an acute commentary on the disintegrating state of their marriage. It is a perfect small example of Sickert's two-figure compositions, with an unusual foundation on fact.

Incensed by the war, Sickert was moved by patriotism to attempt military subjects and even wished to go to the front as a war artist, as several of his colleagues had done. Nor was he slow to see the possible benefits to be gained from exhibiting pictures of a highly topical nature. The most significant outcome of these motives, painted in

67

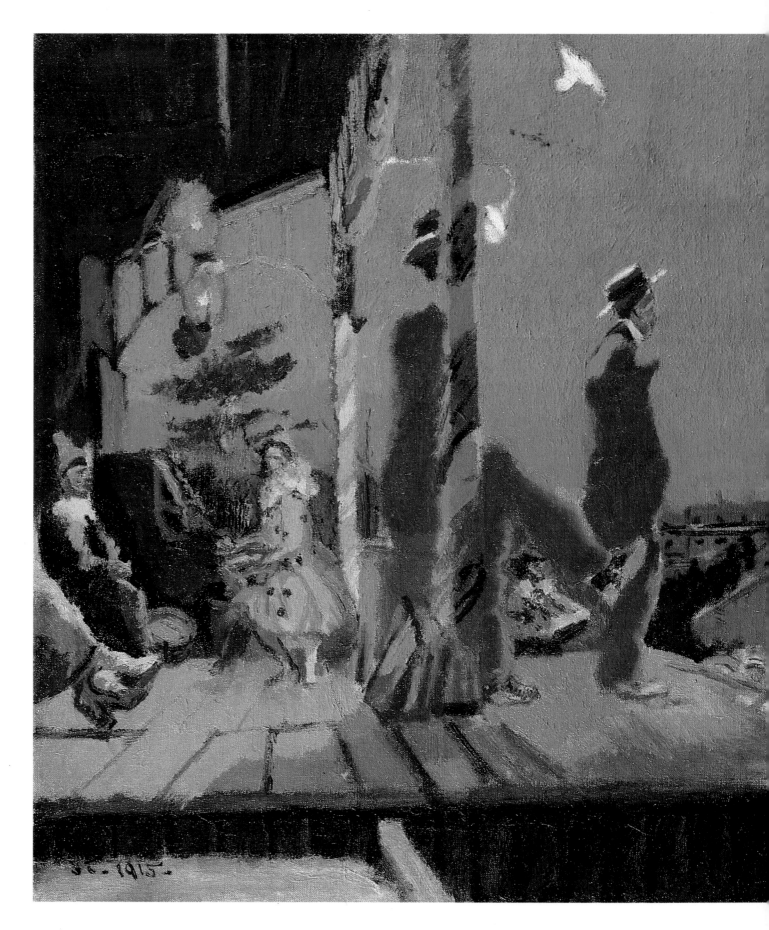

48. Walter Sickert. *The Brighton Pierrots*. 1915. Oil on canvas, 58.4 × 73.6 cm. (23 × 29 in.) Private collection

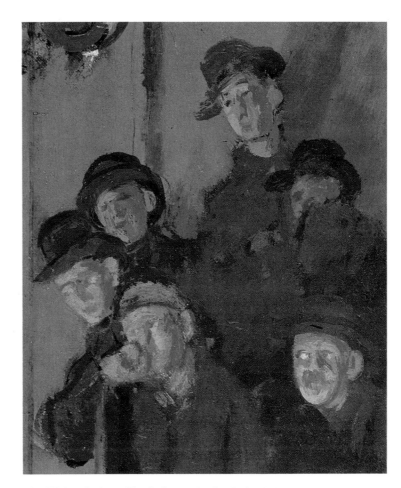

48a. Walter Sickert. *The Gallery of the Old Bedford* (detail of plate 7)

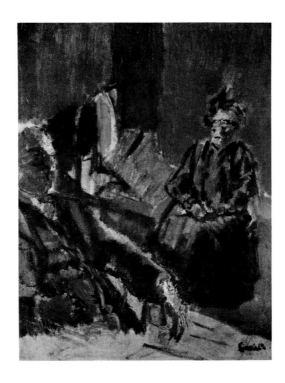

49. Walter Sickert. *That Boy Will Be the Death of Me.* c.1912–13. Oil on canvas, 45.1 × 30.5 cm. (16 × 12 in.) Private collection

the first flush of the war, is *The Soldiers of King Albert the Ready* (Pl. 51). This cool, multi-coloured painting was inspired by a press photograph, although recomposed in the studio with the aid of Belgian soldiers who modelled in uniform. Its dramatic action, large scale and photographic source anticipate much of Sickert's late work, especially the theatre paintings of the early 1930s. It also recalls statements on war in the art of the past, inevitably Goya whose *Disasters of War* etchings Sickert greatly admired and studied, and Manet whose *Execution of Maximilian* (in fragments) was in Degas's collection and seen by Sickert on his visits to the rue Victor Massé. Sickert would also have known Manet's drawings and etchings of Paris in 1870–71, such as the *Guerre Civile* with its foreground corpse.

A few other paintings and drawings testify to Sickert's ambitions as a war artist, and he must have visited a casualty hospital for there are studies of nurses tending wounded men. But he was more successful in suggesting the home front atmosphere of the time in such works as *Tipperary* (his model Chicken at the piano in Sickert's Red Lion Square studio), the famous *Suspense* (Ulster Museum, Belfast), possibly an indirect comment on the war, or the portrait of his son Maurice Villain in uniform. The unusual *Sinn Féiner* (Pl. 55) is a reminder of another war elsewhere.

Sickert's enforced presence in England saw his return to landscape and urban subjects; the English countryside and county town replaced Dieppe and its environs. He visited Chagford in Devon and found himself captivated by the churchyard, its tombstones in rows like the heads of a music hall audience. In full sun he made a study of the village shop with a cyclist peering into the window, later enlarged and transferred to canvas (Pl. 54). The motif of a shop or part of a building shown parallel to the picture plane was by no means a new subject. It appears, for example, in several etchings of 1884 influenced by Whistler. Seated or standing figures counteract the geometry of

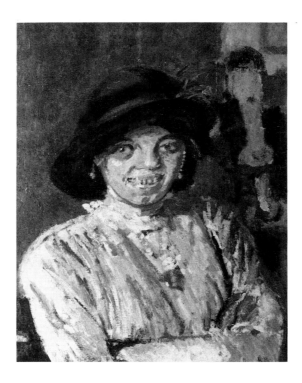

50. Walter Sickert. *Chicken*. c.1914. Oil on canvas, 50.8 × 40.6 cm. (20 × 16 in.) England, private collection

doors and windows and suggest daily activities. A man waits for a train in the shadows of an underground station (*Queen's Road Station, Bayswater*, Pl. 53); a woman attends to her washing in *The Hanging Gardens of Islington*. Shop and house fronts become a recurrent later subject: Thorne's in *Barnsbury* (a reprise of Sickert's 1884 etching *Sixpence Three Farthings, St John's Wood High Street*), Dawson's in *Easter*, in which a child gazes enraptured at windows full of seasonal bonnets, and a group of very late works such as *A Scrubbing of the Doorstep* and Mrs Sickert glimpsed in *The Open Window* (1939, Leeds City Art Gallery), looking onto the Sickerts' garden near Bath.

At the same time in Chagford, and in the following two years on visits to Bath, Sickert returned to pure landscape, often preferring highly picturesque subjects such as *Rushford Mill, Devon* (Fitzwilliam Museum, Cambridge). They are not among his great works but they add a further dimension to the increasing variety of his subject matter; he seemed prepared to tackle almost anything in a loosening of the reins after the Camden Town period of darkened interiors and figures. Even still life makes an appearance with some hanging pheasants in 1917 and a winning group of works of 1919, celebrating Christine Sickert's *bonne cuisine* and a return to French fare in *Roquefort* (Tate Gallery), *Lobster on a Tray* (Kirkcaldy Art Gallery) and fish from the market in Dieppe. All are treated with an elegance Sickert admired in the still lifes of Manet, that 'magnificent painter of the *morceau*' as he called him.

In Bath, where he spent long periods between 1916 and 1918, Sickert returned to urban architecture, making full use of the city's unexpected vistas, glimpses of the countryside above the rooftops, the contrast of stone and water (especially in his many versions of Pulteney Bridge). 'Bath is *it*,' he wrote to Ethel Sands. 'There never was such a place for rest and comfort and leisurely work. Such country, and *such* town.' In many of the Bath paintings Sickert's squaring-up process remains particularly apparent. The colour, while often high in key, is dry and scrubby,

71

built up on a camaieu of two colours, each of two tones. There is a noticeable speed in the overpainting and, though we know many of the works were done in the studio from studies (and some completed later in London), there are a few panels painted out of doors. This seems to have been the last occasion on which Sickert worked directly in front of the subject. Simultaneously from Bath, there are several drawings and watercolours with all the topographical detail of the English watercolour school of a century or more earlier; presumably Sickert thought they might sell well as had some similar watercolour drawings of Dieppe. In most of these Bath paintings, Sickert seems to be holding fire, making little attempt to follow through the grander implications of the *Soldiers of King Albert*. Such holiday works, full of charm, verve and a classic economy of means which was suited to the crescents and squares of the city, take us no further in Sickert's exploration of oil paint, save in the sometimes startling, almost *fauve*, inventions of briskly applied colour.

Sickert's return to Dieppe after the war is marked by a considerable revival in his work, especially in a series of café and casino paintings. Vernet's, situated in the arcades, was the subject of interiors and of paintings of its clients outside at tables under the arches (Pl. 59). In the evenings there would be a singer and pianist, the former seen in several drawings and paintings (Pl. 58). Although they are reminiscent of the music hall interiors of twenty years or more before, the contemporaneity of the subject is matched by Sickert's free, vivid handling and heightened colour. This becomes more apparent in the Dieppe casino paintings, in most of which baccarat is being played by fashionably dressed people lit by low-hanging lights above the tables (Pls. 61, 62). Figures are heavily outlined in a complex jigsaw of overlapping forms; the paint is dry and thinly applied, with the weave of the canvas allowed to show through. There is a brittle quality to some of these works and sharp accents of highly artificial colour and dark shadows add to the late-night atmosphere of the rich (and perhaps not so rich) at play. In these groups of concentrating people around the baize-topped tables, Sickert may consciously be echoing the dice- and card-playing scenes of early seventeenth-century painting; he may even have known the copy in the Dieppe Chambre de Commerce of Valentin's *Card Players*. Although such works were less exhibited and documented then than now, Sickert's catholic tastes among the more obscure Old Masters and his habitual scouring of the salerooms, might allow such speculation in the absence of any direct evidence. At the same time the choice of subject and freedom of colour are points of contact with contemporaries such as Van Dongen, Dufy and Charles Demuth.

Some of these works were painted during anxious months and later during ones of grief. A swift decline in the health of Sickert's wife, Christine, took place in 1920 and ended with her death in October that year. Sickert was badly shaken, a state complicated by feelings of guilt from the thought that he had neglected obvious earlier signs of Christine's illness. His behaviour became erratic and increasingly eccentric; he shut himself off in Dieppe seeing only the devoted Sylvia Gosse and Ethel Sands. There seems to have been a period of delayed shock, partly owing to his unpreparedness for his uncomplaining wife's death. According to one witness, Sickert felt that 'the mainspring was broken' and that the indifferent quality of his subsequent work is attributable to the event. It is true that for the next few years there is something directionless about his work, but the suggestion is hard to reconcile with such splendid paintings as *Victor Lecour* (Pl. 60) or *The Bar Parlour* (Pl. 65). Certainly Sickert's own health caused him worry during these years. He had written to Nina Hamnett from Bath that 'I am not surprised or injured that 2 years off sixty I may be having to take in sail.' There were increasingly heavy colds, attacks of influenza, eye trouble and in 1926 what was probably a slight stroke. But by then Sickert had embarked on one of the busiest and most productive phases of his career.

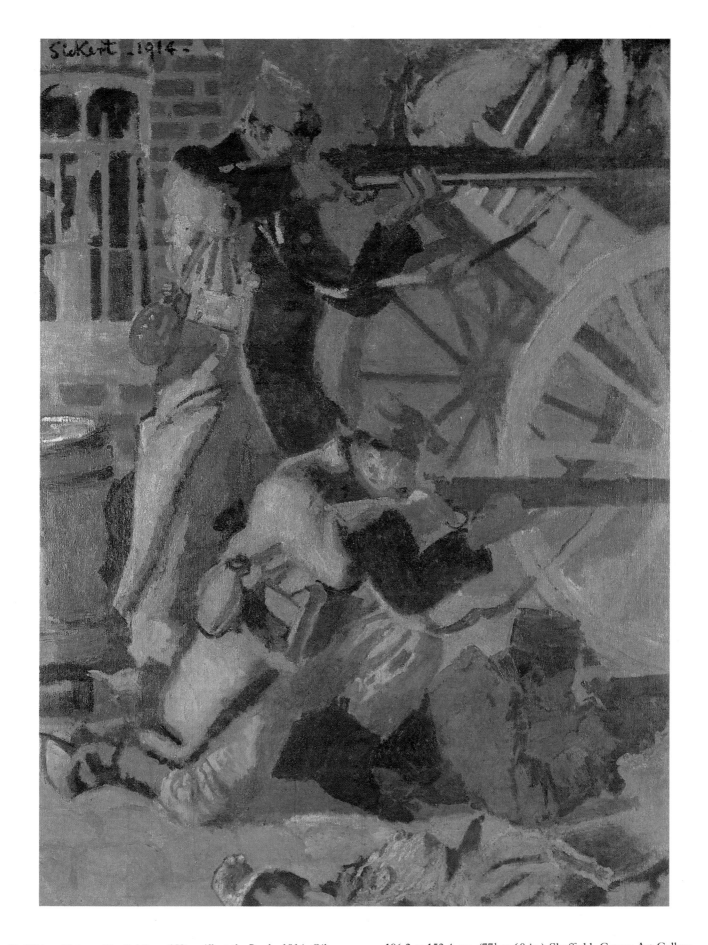

51. Walter Sickert. *The Soldiers of King Albert the Ready.* 1914. Oil on canvas, 196.2 × 152.4 cm. (77¼ × 60 in.) Sheffield, Graves Art Gallery

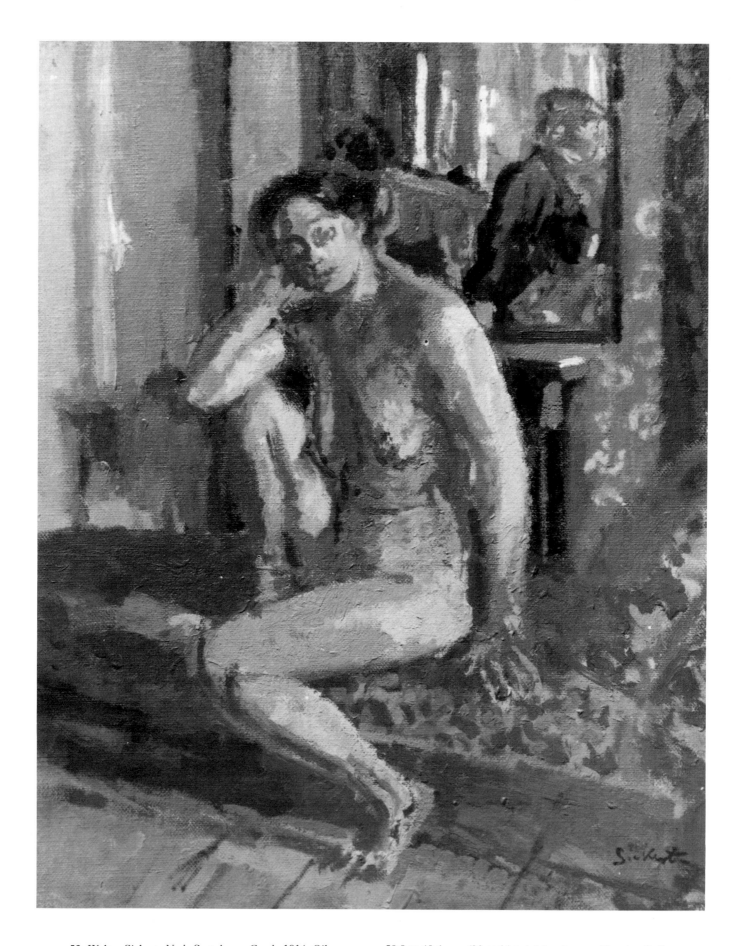

52. Walter Sickert. *Nude Seated on a Couch.* 1914. Oil on canvas, 50.8 × 40.6 cm. (20 × 16 in.) Manchester, City Art Gallery

——— FIVE ———

SICKERT'S LATER YEARS

The facts of Sickert's late years can be briefly summarized. The intention of living permanently once more in France was dashed by Christine's death and in 1922 he eventually returned to London. From various accounts he was still in poor spirits, though he painted and wrote with zest. He led a comfortless existence in a room next to his studio at 15 Fitzroy Street (his other studio at number 8 had been taken over by Duncan Grant in 1920). He was short of money and temporarily had no teaching job to sustain him. He turned his back on most of his friends and locked his door. 'He had towering steel gates erected at vast expense,' his friend Marjorie Lilly was to write, 'across the entrance to the Frith [the nickname of his studio, once occupied by Frith of *Derby Day*] which met with an ominous clash like the lifts in London tube stations, fastened with an enormous padlock, and to crown all he kept a large dog on the premises in case intruders were not already sufficiently discouraged.' But eventually, with the help of two or three people, Sickert returned to something like his previous cheerfulness and resilient professionalism.

One of those friends was the painter Thérèse Lessore (1884–1945), whom Sickert had long admired as an artist and whom he married in 1926. Another was W. H. Stephenson from Southport, who bought Sickert's work, put in train the painter's desire to be elected to the Royal Academy (he was duly made an A.R.A. in 1924) and arranged for him to lecture in Southport and to contribute six articles on French and British art to *The Southport Visiter* in April and May 1924. A third person of inestimable value at this time was Cicely Hey, a young painter and freelance draughtsman. She was selling tickets at the door for a lecture given by Roger Fry (17 January 1923) when Sickert noticed her and asked her to model for him on the following day. She did so continually until May (and occasionally thereafter) and became a close friend. Several paintings resulted, notably the ghoulish *Cicely Hey* (Pl. 66) in which she appears as a stage performer lit by footlights from below. Miss Hey married Robert Tatlock, then editor of *The Burlington Magazine*, to which Sickert had contributed articles and reviews since 1915.

By the mid-1920s Sickert had fully resumed all his activities and in 1927 opened his last private teaching school, at 1 Highbury Place, Islington. His yearly submissions to the Royal Academy summer exhibitions from 1925 onwards began to attract enormous publicity and the following years saw his emergence as a not unwilling, though sometimes irascible celebrity. This phase in his life was marked by his change of name from Walter to Richard Sickert (1927) and by a stream of letters to the press, often in his most multi-lingual vein. His personal and domestic style reached new heights of eccentricity even for Sickert. He could be extraordinarily contrary, agreeing one moment to something he had violently opposed the day before, and throwing official meetings into charmed uproar. At a deputation, for example, from his supporters in the Royal Society of British Artists, when Sickert's presidency was being questioned, he turned to one member

who had suggested as a joke that she herself might replace him: 'Oh do, that would be splendid, and then I should come under your skirts! There is nothing I like so much as an irregular position!' His bawdy humour, in the music hall tradition, was noted when he visited Henry Moore's 1931 Leicester Galleries exhibition of carvings. 'I had to use a very special tool to do her,' Moore remarked seriously. 'I think I would need one too,' replied Sickert, in an equally serious voice.

Sickert's views on painting and the artists he admired continued to be expressed with wit and lucidity; reviews and lectures find him passionately protesting the merits of some forgotten Victorian illustrator at the expense of the applauded names of his day. He saw little point in assassinating past reputations. For Sickert tradition was a live thing and cumulative; only dishonesty and the *on dit* of fashionable criticism roused his contempt. To some extent he shared the scorn in which High Victorian painting was then held, not because it told a story but because it often told it badly. Holman Hunt is castigated for his obscure and enigmatic interpretation of the Bible. 'What is the young tent-maker doing to the young lady in the yashmak?' he enquired of readers of the *Manchester Guardian*. Millais, greatly admired for his early work, later became 'the most powerful and demoralising factor in British Art'; but Frith could tell a story, Madox Brown had a 'desperately convinced genius' and Lord Leighton (whom Sickert had met and liked) was the epitome of fine draughtsmanship. Sickert delighted in the aggravation such opinions caused among his friends; in his Highbury studio he hung a reproduction of Landseer's *Monarch of the Glen* 'pour emmerder Roger Fry' as he told the young Quentin Bell.

Although Sickert might publicly deplore the views of Roger Fry and Clive Bell with teasing sharpness, in private he was welcomed into the critics' circle of friends with increasing warmth. His friendships within Bloomsbury were not deep, though his long relationship with Fry, six years his junior, had about it the depth of all amiable and savoured sparring, and Sickert and his family had been helpful to Fry when his wife's mental illness first became apparent. Sickert's profoundest feelings for his fellow human beings are difficult to gauge. Often for trivial reasons, he broke with old friends; his immense egoism perhaps prevented the long-term give-and-take of such relationships. By the 1920s he rarely saw Rothenstein and Blanche; he had quarrelled with George Moore (and fired an unusually acerbic broadside in 1914 at Moore's opinions on the teaching of art); younger painters drifted in and out of his life and there had been no one to replace Spencer Gore. For a while, Bloomsbury provided an admiring and agreeable social backdrop to his life before his marriage to Thérèse Lessore and their eventual move out of London in 1934. He was a guest of Clive Bell in Gordon Square, attended several Bloomsbury parties (eagerly taking part in theatrical performances) and became the subject of one of Virginia Woolf's most celebrated essays, *Walter Sickert. A Conversation*, published in 1934. Inspired by a show of Sickert's work at Agnew's in November 1933, the essay is a long after-dinner conversation about Sickert and his work. With a characteristic blend of fact and fantasy, the author puts forward her view of the paintings as literature, thus flying in the face of the popular conception of her circle's purely formal interpretation of art. At the centre of the discussion lies Virginia Woolf's celebrated account of her reactions to *Ennui*. Sickert was elated. 'I have always been a literary painter, thank goodness, like all the decent painters,' he had written to her. 'Do be the first to say so.' And she was.

In 1927 Sickert had moved with his new wife to Islington where for some years he had had a studio in Noel Street (now Noel Road). His passion for acquiring studios was abating, though he kept one in Brighton (1926–31) and used another at the back of a house in Camden Road (until c.1934). He had too his studio-cum-atelier in Highbury (not far from his home) with its deep red wallpaper, mounted stag's head, framed Victorian engravings and the intermittent yelling of patients from the dentist next door. London life is the subject of many paintings in the

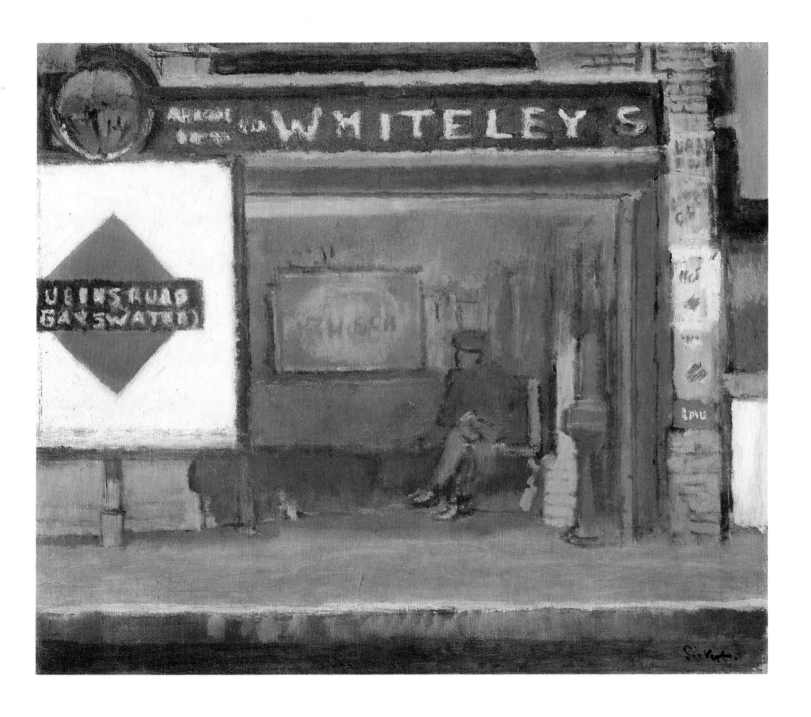

53. Walter Sickert. *Queen's Road Station, Bayswater.* c.1916. Oil on canvas, 63.5 × 76.2 cm. (25 × 30 in.) London, Courtauld Institute Galleries, Fry Collection

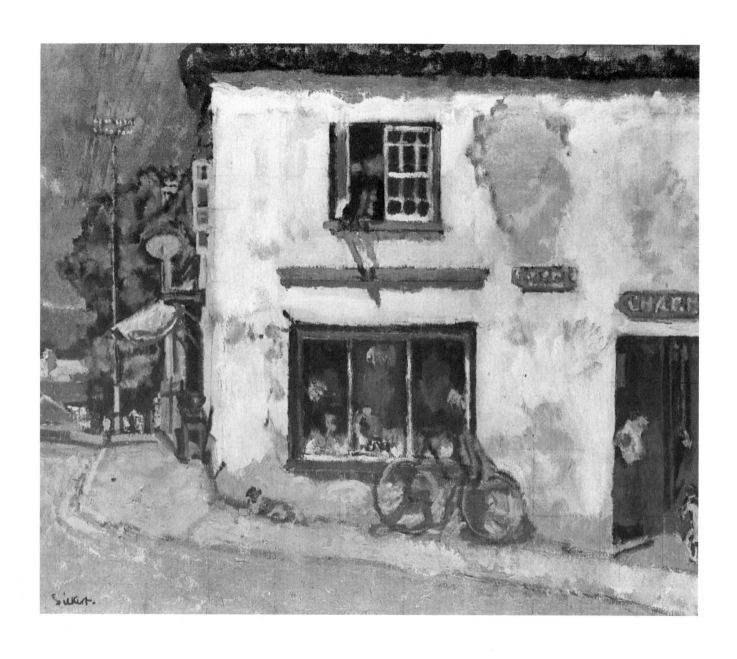

54. Walter Sickert. *The Shop, Chagford.* c.1915–16. Oil on canvas, 45.7 × 55.7 cm. (18 × 22 in.) Private collection

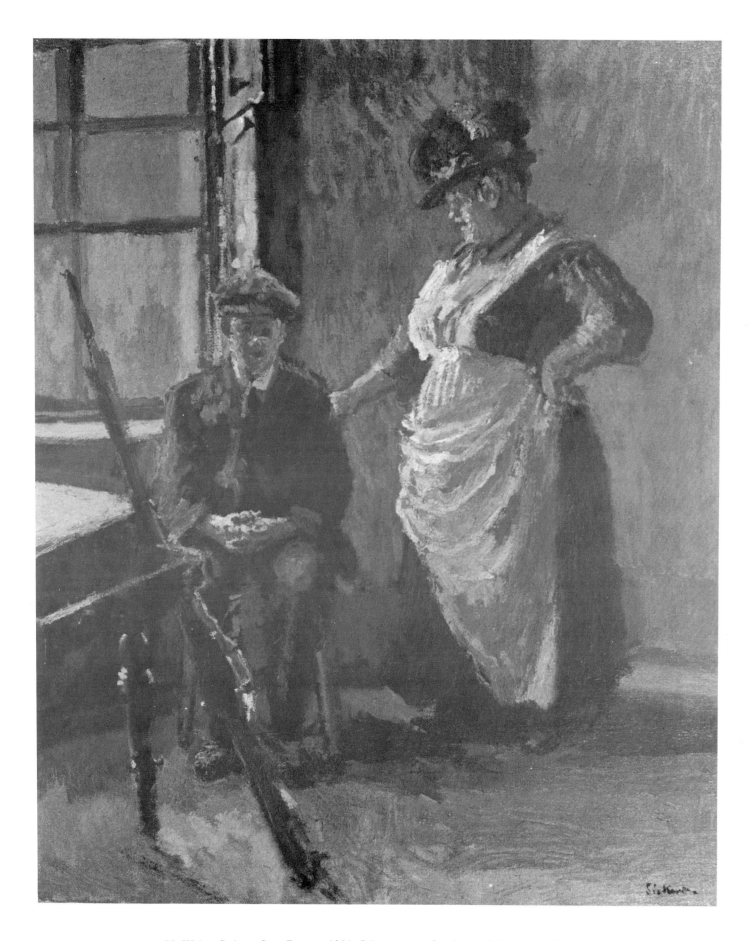

55. Walter Sickert. *Sinn Féiner.* c.1916. Oil on canvas. Southport, Atkinson Art Gallery

56. Walter Sickert. *The Area Steps.* c.1928. Oil on canvas, 56 × 43 cm. (22 × 17 in.) Private collection

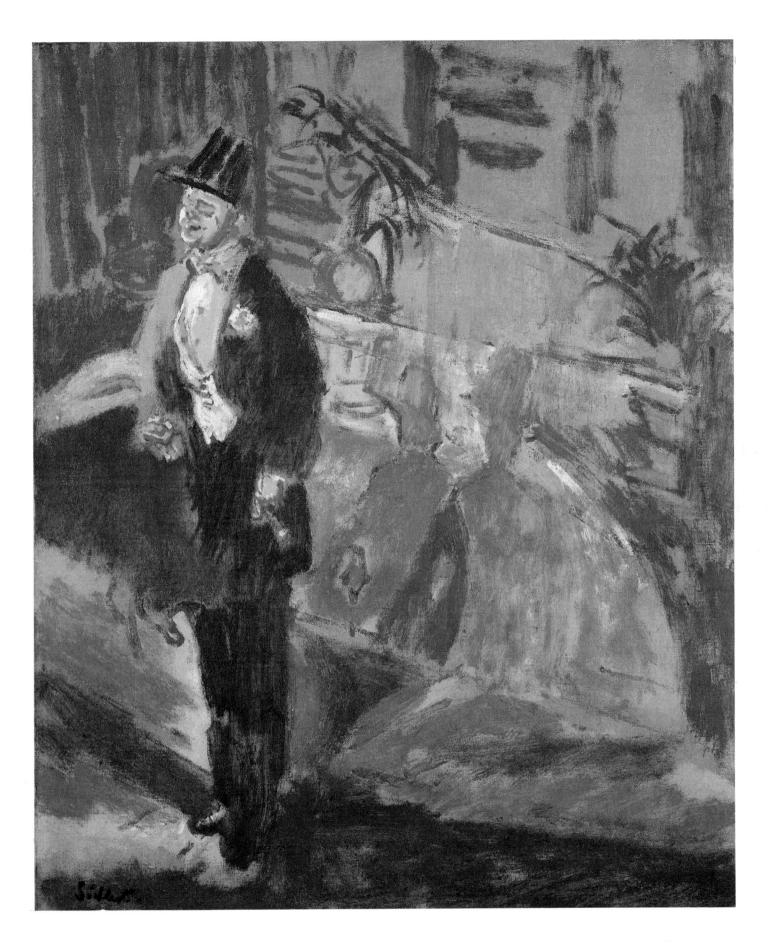

57. Walter Sickert. *That Old-Fashioned Mother of Mine.* c.1920. Oil on canvas, 59.7 × 47.6 cm. (23½ × 18¾ in.) Private collection

1920s, though without that intense concentration on its inhabitants that had marked his work in previous decades. In 1913 he had written to a friend: 'London is spiffing! Such evil racy little faces and such a comfortable feeling of the solid basis of beef and beer. O the whiff of leather and stout from the swing-doors of the pubs!' Most of Sickert's later London paintings are out-of-doors subjects: Regent's Park, the Serpentine in Hyde Park, Islington gardens, a bride leaving her home in Pimlico, a young girl pausing for a moment by the railings of a terraced house on a summer evening (Pl. 56).

In 1934 the Sickerts moved from London to the village of St Peter's-in-Thanet, some miles inland from Margate on the Kent coast. It is probable that the move came about through financial expediency, as much as through the Sickerts' liking for the district, which they had visited on their honeymoon and again in the summer of 1934. Earlier in the year an appeal had been launched by Sickert's executor, Sir Alec Martin of Christie's, begging the painter's friends to relieve him of his 'serious, almost desperate, financial situation'. Over two thousand pounds was raised and invested to rescue Sickert from his extravagance and financial incompetence. Mindful of this, Sickert accepted several portrait commissions, from Martin himself and from the Canadian financier Sir James Dunn. He also began to teach at the Thanet School of Art in Margate (where he also kept a studio) and delivered six lectures there in the autumn of 1934. In his usual fashion, he would taxi from his house, Hauteville, and back again, to deliver his astonishing recipes for successful painting, mingled with memories of Sir John Gilbert and Johnstone Forbes-Robertson. He propounded with customary force and humour his theory of drawing. There were three stages: the soft tentative line, rapidly done ('If you were shooting birds and you shot them slowly it would not be much good; you can only shoot them at all by shooting quickly'); next the disposition of light and shade; and last the definitive line. He stressed the importance of drawing to the scale of vision, of starting a drawing in one place and working outwards, of having a 'core' right from the start—the eclipse of one head by another, for example, to establish at once a three-dimensional quality. 'Any fool can paint, but drawing is the thing and drawing is the test.' His instructions for painting were becoming even more didactic and impersonal. The drawing should be squared for enlargement and then, by tracing, transferred to a well-prepared canvas. The subject is then blocked in with no more than two or three colours, using them with white in the lightest parts of the painting which are reached only by painting the darkest areas first. 'It is convenient if your cameo is of colour opposed to the colours which will eventually go on the canvas.' This is allowed to dry thoroughly before further applications are made, again dark before light, colour sparingly used, chosen from memory, the imagination or colour notes made at the time of the original drawing. The drying time allowed between successive layers varied considerably; '. . . it is no use getting irritated over the weather or your materials because they won't dry quick enough . . . it is as well therefore that you should have more than one iron in the fire so that you can start a picture on a Monday, put it down to dry, start another one on Tuesday and so on so that you have four or five things which you are painting at the same time It is far better to do what I have described than to sit pegging away at the same thing until your stomach turns at it.' Above all, Sickert admired economy of means, work carried through from start to finish with an absorbed detachment in which, as he wrote in 1924, 'a man is able to seize and digest something which is extremely complicated . . . and give it out so that it looks as though it had been said in a breath, as though it were the easiest thing in the world'

Although Sickert's methods could be followed through with room for individual inflections, they were really instructions on how to paint a Sickert. His own students, if strong enough, took what they needed and went their own ways. But in fact, Sickert's personality being so dominant, few, if any, of the later pupils emerged with much personal

58. Walter Sickert. *Au Caboulet au bout du quai* (Vernet's, Dieppe). c.1920. 61.3 × 50.8 cm. (24⅛ × 20 in.) Montreal, Museum of Fine Arts

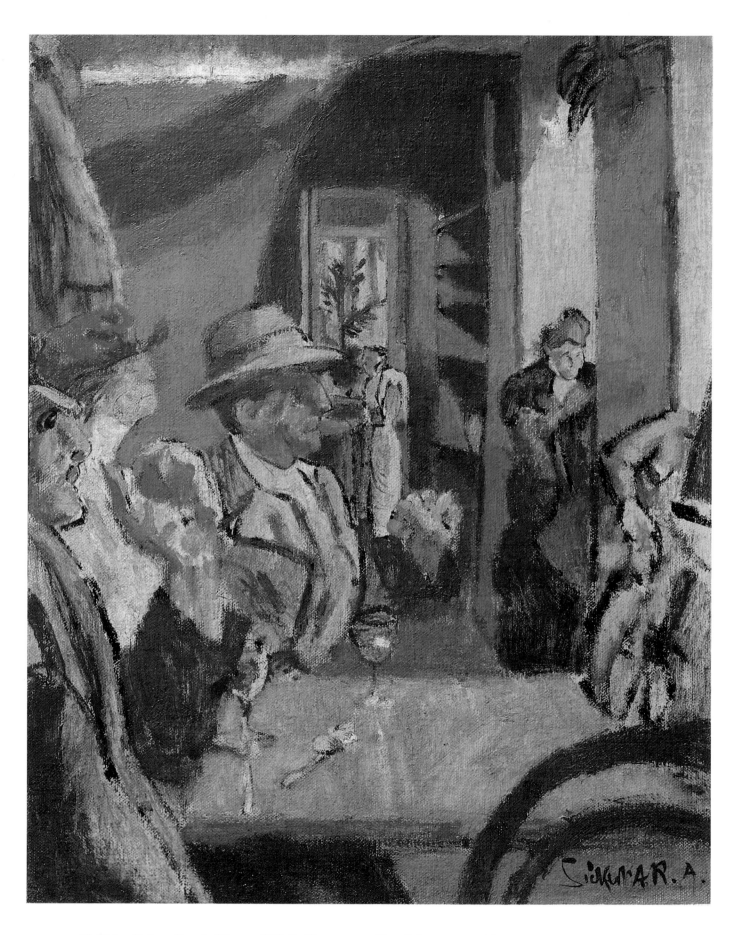

59. Walter Sickert. *Vernet's, Dieppe.* c.1920–2. Oil on canvas, 61 × 49.5 cm. (24 × 19½ in.) London, private collection

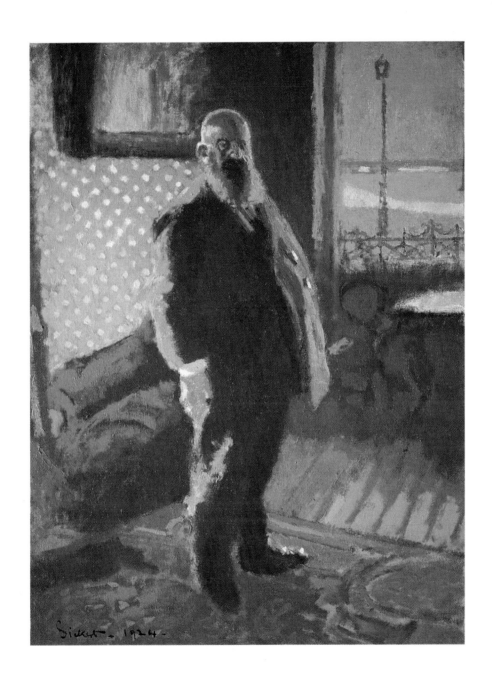

60. Walter Sickert. *Victor Lecour.* 1922–4. Oil on canvas, 81.3 × 60.3 cm. (32 × 23¾ in.) Manchester, City Art Gallery

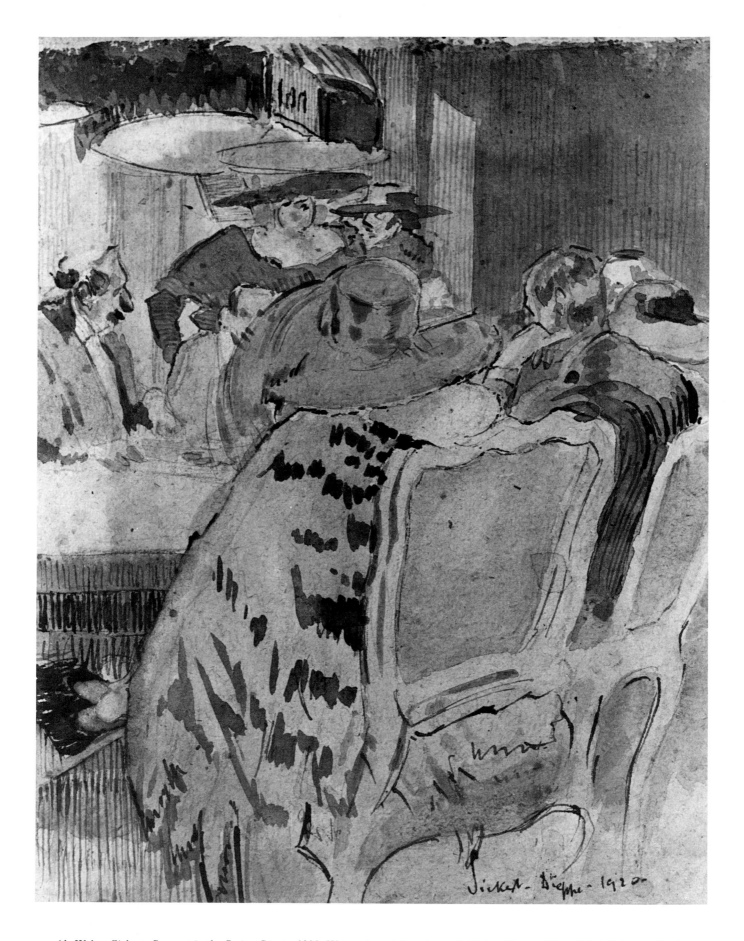

61. Walter Sickert. *Baccarat in the Casino, Dieppe.* 1920. Watercolour, ink and pencil, 25.4 × 21 cm. (10 × 8¼ in.) Private collection

62. Walter Sickert. *Baccarat* (Dieppe Casino). 1920. Oil on canvas, 61 × 45.7 cm. (24 × 18 in.) The Cottesloe Trustees

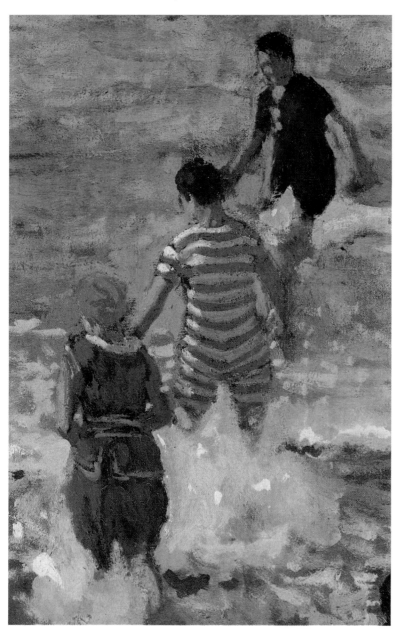

62a. Walter Sickert. *The Bathers, Dieppe* (detail of plate 18)

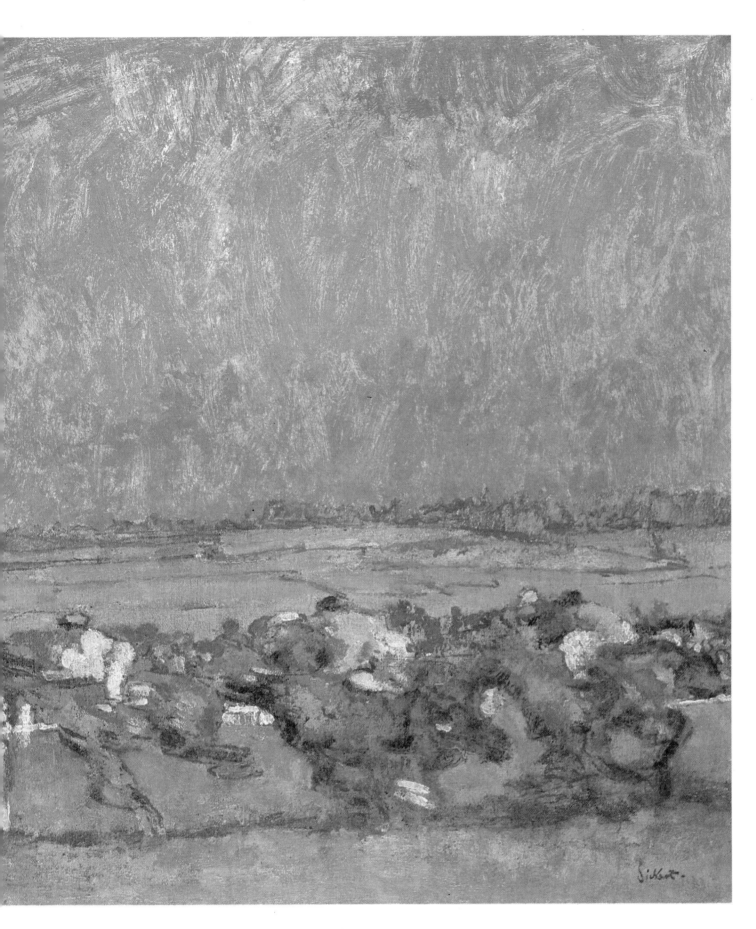

63. Walter Sickert. *Dieppe Races.* c.1924–6. Oil on canvas, 50.8 × 61 cm. (20 × 24 in.) Birmingham, City Art Gallery

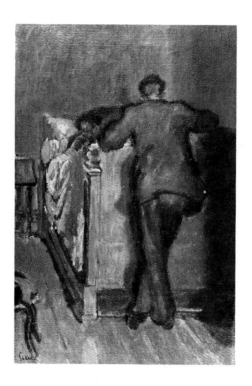

64. Walter Sickert. *The Prevaricator.* c.1920–2. Oil on canvas, 61 × 40.6 cm. (23¾ × 15¾ in.) Private collection

vision and none can claim much more than a reputation as a 'pupil of Sickert'. One student, at Highbury Place, was Mark Oliver, a well-known collector of Sickert's work who was famous, according to his obituary in *The Times* (27 July 1987) for introducing tea as a commercial crop in Guatemala. Other pupils included Lord Methuen and the South African Morland Lewis who at one point, as studio assistant, seems to have painted most of the canvas before Sickert took over with his final additions and signature. Another pupil, Robert Emmons, had a gift for writing, however, and in 1940 published *The Life and Opinions of Walter Richard Sickert*, an indispensable sourcebook of fact, quotation and *obiter dicta.*

By the time it was published, Sickert was certainly among the best-known English painters, though still with little reputation abroad. His influence in England, however, was largely indirect, theoretical rather than practical. Perhaps closest in their sympathies and objective approach were some of the Euston Road School painters towards the end of the 1930s. Certainly Graham Bell and William Coldstream came under his influence, particularly in their pub and café interiors; some of Victor Pasmore's work, such as *The Jewish Model*, and the interiors with nudes by Pasmore, Claude Rogers and Rodrigo Moynihan owe something in their conception of subject and tonal arrangement to Sickert. But though connections can be made between Sickert and the sober realism of the Euston Road painters, it was to his earlier work that they looked for confirmation. The Pasmore portrait (in the Tate Gallery), in its vivid, local human presence and sombre, accented colour is nearer to *Chicken* (Pl. 50) or *The Black Bird of Paradise* (Pl. 31) than to Sickert's later portraits. And the interiors with women by Geoffrey Tibble, mainly of the 1940s, owe much to Sickert's practice and precepts of the Venetian and Camden Town periods—of women in

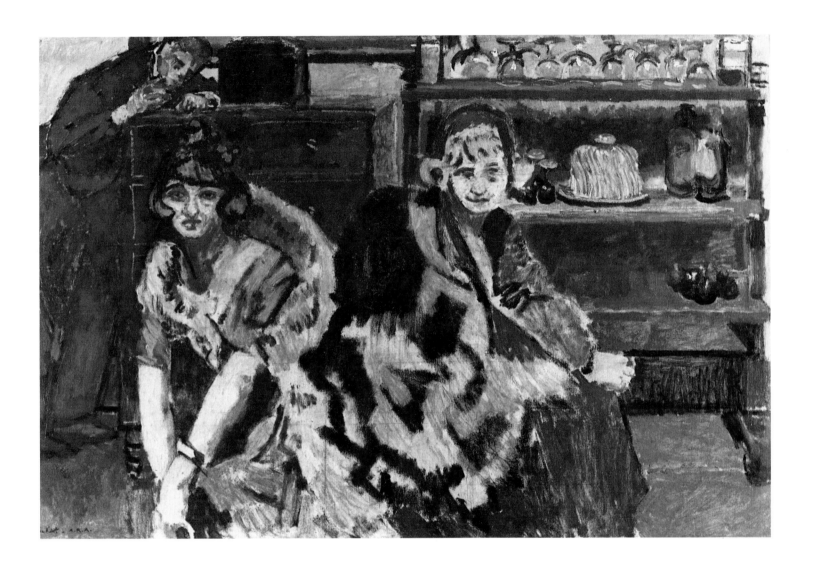

65. Walter Sickert. *The Bar Parlour.* 1922. Oil on canvas, 104.1 × 157.5 cm. (41 × 62 in.) Cambridge, King's College, Keynes Collection

66. Walter Sickert. *Portrait of Cicely Hey*. 1922–3. Oil on canvas, 75.5 × 35.2 cm. (29¾ × 13⅞ in.) Private collection

rooms engaged in conversation or domestic activities, a generally low colour scheme, raised viewpoint and modest intimacy of scale. It is worth noting however that the drawings of these painters, of Coldstream and Rogers in particular, are often closer to those of Harold Gilman and Spencer Gore, than to the more obviously painterly drawings of Sickert. Another artist whose early work owes much to Sickert's subject matter and handling was Edward le Bas, who owned a fine collection of Sickert's paintings and drawings, including *Chicken* and the late landscape *91 Albion Road*. Quite a number of painters have owned works by Sickert, most famously Paul Signac who purchased *L'Affaire de Camden Town* in 1909; English artists include Keith Baynes, Vanessa Bell, Roger Fry (who owned *Queen's Road Station, Bayswater*, Pl. 53), Fred Uhlman, Rodrigo Moynihan, Francis Bacon and Howard Hodgkin. So varied a list testifies to the continual vitality of Sickert's work and the interpretative possibilities it affords.

One of Sickert's last appearances in London was to talk to the Euston Road School in summer 1938. Later that year he and Thérèse moved once more, to St George's Hill House, Bathampton, near Bath. It was here that Sickert spent the last three years of his life. He was by now bulky, biblically bearded, increasingly frail but still able to work with Thérèse's considerable help, and his last pictures date from 1940 into 1941. His talk became rambling and mainly centred on his spectacular past, 'with only few flashes of the war today', as Cecil Beaton recorded when he came to photograph the Sickerts. A series of small strokes in 1941 gradually reduced him to confinement to his room and he gave up the classes he took at the Bath Academy of Art. Apparently he was just aware of the large retrospective of his work that was held at the National Gallery in the autumn of 1941. A few months later Sickert died, aged eighty-one, on 22 January 1942.

67. Walter Sickert. *The Raising of Lazarus*. c.1929–32. Oil on canvas, 243.9 × 91.5 cm. (96 × 36 in.) Melbourne, National Gallery of Victoria

68. Walter Sickert. *A Conversation Piece at Aintree (King George V and his Racing Manager)*. c.1927–8. Oil on canvas, 47 × 47 cm. (18½ × 18½ in.).
By gracious permission of H.M. Queen Elizabeth The Queen Mother

THE LATE WORK

In recent years, the rediscovery of the late work of artists better known for their earlier achievements has provided some exciting reassessments. Not only have unsuspected characteristics been revealed but also the relationship of an artist's late work to the contemporary art of its time has illuminated both. There have been fundamental revisions of late Monet, Bonnard and Picasso, of Beckmann and Derain, Guston and Bomberg. The late work of Sickert has long been controversial and an exhibition in 1981 devoted specifically to this period was received with a mixture of enthusiasm, distaste and disbelief.

A late work by Sickert can be defined loosely as having the following characteristics. It was painted after about 1926; it is in oil on often coarsely textured canvas; it is large in size, relative to his earlier work; it has as its source a nineteenth-century black and white wood engraving or a photograph either from the press or one taken under Sickert's direction. In the series known as the 'Echoes' (c.1927–c.1940, the bulk belonging to the early 1930s) his subject matter is of nineteenth-century domestic, public and dramatic incidents. The rest of the late work is marked by a parallel concern with the recording of the public figures, activities, pastimes and the artist's domestic life of the 1930s. The works were carried out in Sickert's studio, often with the help of Thérèse Sickert, Sylvia Gosse and Morland Lewis, and were made from squared drawings and photographs transferred to canvas, the process usually remaining visible in the final work.

Sickert painted a number of celebrated men and women in the news or in public life, usually from press photographs, occasionally from direct contact and photographs taken by Thérèse. They include George V and Queen Mary (Pl. 90), Edward VIII (Pl. 70), Churchill and Beaverbrook; men and women from the world of the arts—Beecham (Pl. 85), Goossens, the singers Battistini, Conchita Supervia, and Toti dal Monte (Pl. 91), the novelist Hugh Walpole (Pl. 69); men from Sickert's own professional life, such as his patron Sir James Dunn (Pl. 77), the dealer Duncan MacDonald of the Lefevre Gallery and Sir Alec Martin of Christie's (Pl. 75). Several figures in the news include the aviator Amelia Earhart and the Italian delegate to the League of Nations, Baron Aloisi (Pl. 76); portraits drawn from society include the *Express*'s William Hickey columnist Viscount Castlerosse (Pl. 78) and the newly married Margaret Sweeney, later the Duchess of Argyll (Pl. 89); and there were commissions from members of the aristocracy (with some personal connection with the artist), such as Lady Berwick (Pl. 73), the Hon. Lady Fry and Lord Faringdon (Pl. 74). A further sizeable group of works concentrates on the contemporary stage, particularly productions at the Old Vic, Sadler's Wells (near Sickert's Islington home), the New Theatre and the Savoy. The scenes selected were mainly from plays by Shakespeare but also include works by Marlowe, Sheridan and Goldsmith. They show some of the best-known classic performers of the day such as Peggy Ashcroft (painted many times), John Gielgud, Edith Evans, Valerie Tudor and Nigel Playfair. Some of the players regularly depicted, such as Gwen Ffrangçon-

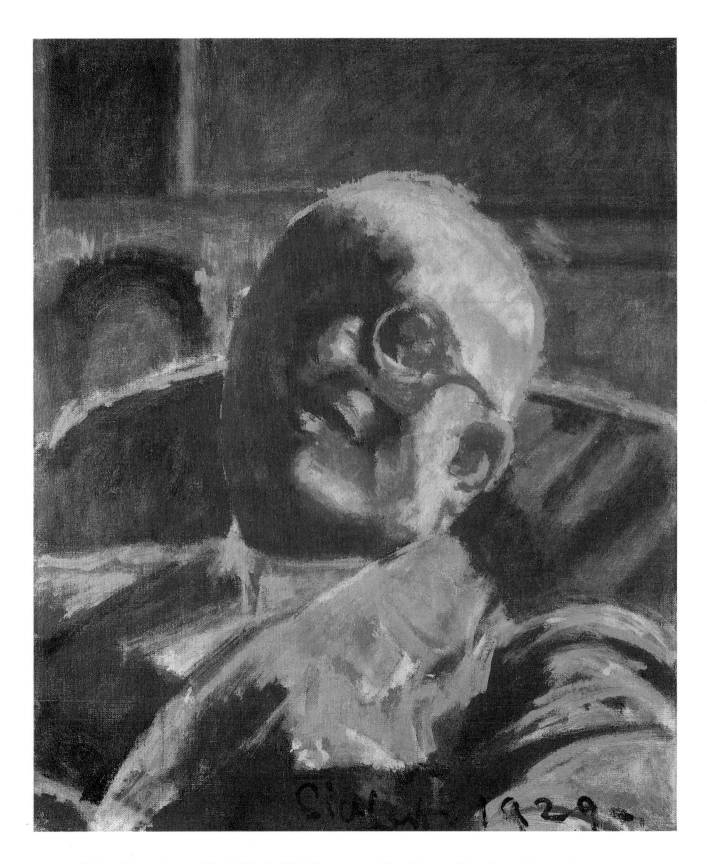

69. Walter Sickert. *Portrait of Hugh Walpole*. 1929. Oil on canvas, 76 × 63.5 cm. (30 × 25 in.) Glasgow, City Art Gallery

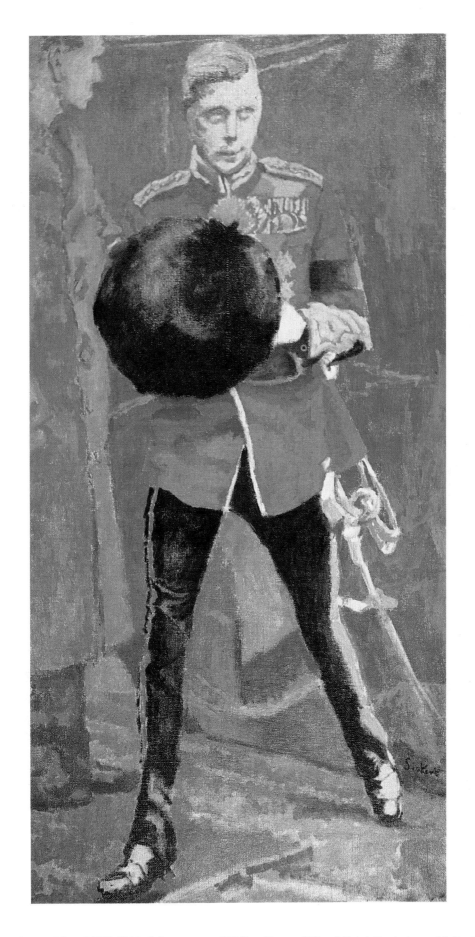

70. Walter Sickert. *H.M. King Edward VIII*. 1936. Oil on canvas, 183.5 × 92 cm. (72¼ × 36¼ in.) Fredericton, N. B., Beaverbrook Art Gallery

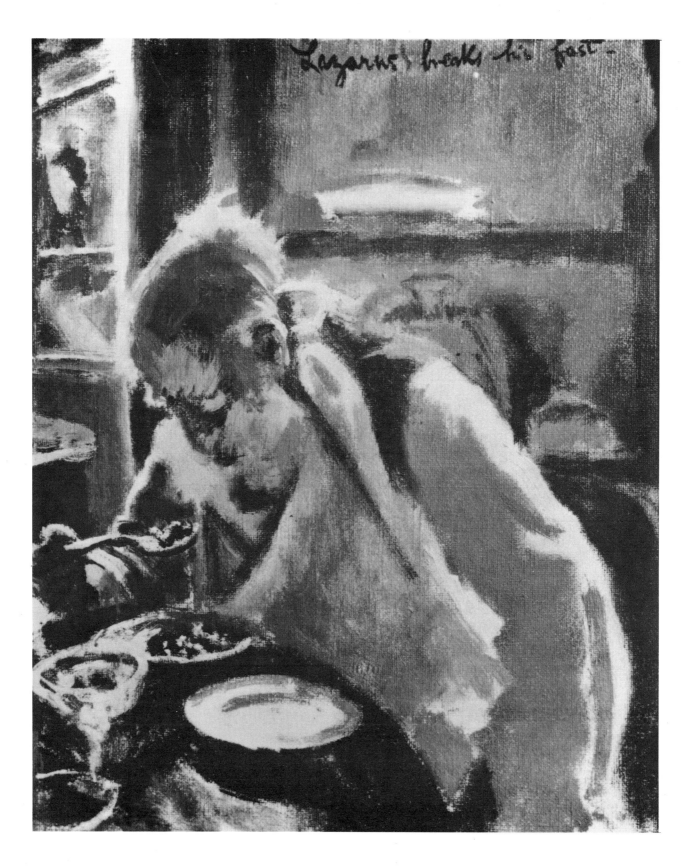

71. Walter Sickert. *Lazarus Breaks his Fast. Self-Portrait.* c.1927. Oil on canvas, 76.2 × 63.5 cm. (30 × 25 in.) London, Mr and Mrs Eric Estorick

72. Walter Sickert. *The Servant of Abraham.* c.1928–9. Oil on canvas, 61 × 50.8 cm. (24 × 20 in.) London, Tate Gallery

Davies, became Sickert's friends. Peggy Ashcroft he knew less well and informal pictures of her in a bathing suit and on holiday in Venice were painted from photographs. Older figures from the English theatre include Dame Marie Tempest and Sir Johnstone Forbes-Robertson as Hamlet in the painting *Sweet Prince* (c. 1931–32), a homage to an old friend and hero. *Jack and Jill* (Pl. 96), which shows Joan Blondell and Edward G. Robinson in the 1936 *Bullets and Ballots*, seems to be the only painting from a contemporary film. This is perhaps surprising, as Sickert certainly enjoyed going to the cinema in London; the painter Keith Baynes remembered accompanying Sickert and Thérèse to a Mae West film – 'a huge success'. He also attended ballets at the Coliseum, and the circus, though this entertainment became the subject of many of Thérèse's works, rather than Sickert's. Theatre pictures are rare (and none shows the audience, as the earlier ones do).

Sickert's last music hall paintings were made after a visit to London from Dieppe in 1920; they are of the London, Shoreditch (also known as the Empire), and the Shoreditch Olympia (formerly the Standard) where Talbot O'Farrell, the 'immaculate singer of Irish songs' was appearing (Pl. 57). Sickert was sufficiently taken with the singer's winning stance and amusing shadows to make him the subject of a brilliant etching some years later. It formed part of a series published by the Leicester Galleries in 1928 and 1929. Among the others was *Cheerio*, showing the breezy finale of an appearance by the Plaza Tiller Girls, the subject of a painting of the same period (Pl. 86). Sickert selected from an accumulated morass of prints, news cuttings and photographs, and it was not until about 1938 that he used a press photo of the same chorus line taken from the London *Evening News* of November 1927. *High Steppers* (Pl. 92) was his last theatre painting, huge in size, restrained in colour, perfectly fusing those elements of spontaneity and exposed technical procedures which characterize the best works from his final years.

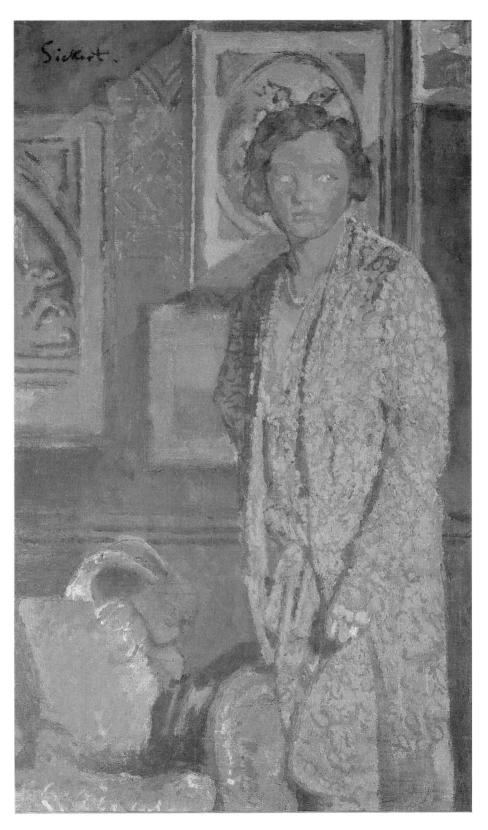

73. Walter Sickert. *Lady in Blue. (Portrait of Lady Berwick).* 1933. Oil on canvas, 152.5 × 91.5 cm. (60 × 36 in.)
Attingham Park, Shropshire, The National Trust

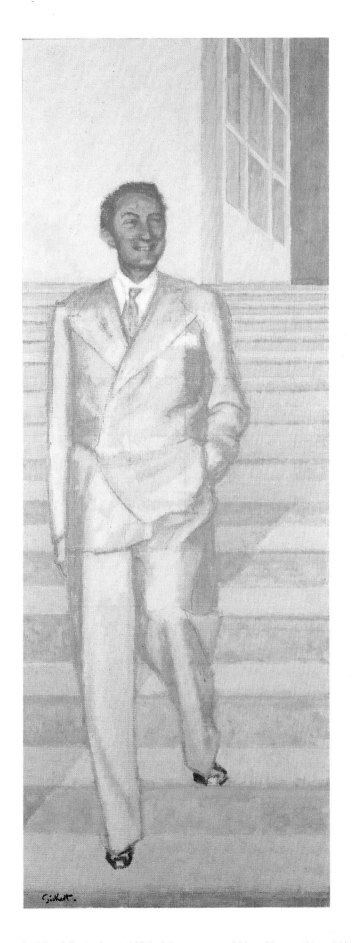

74. Walter Sickert. *Gavin Henderson, 2nd Lord Faringdon.* c.1935. Oil on canvas, 231 × 85 cm. (91 × 33½ in.) Lord Faringdon, Buscot Park

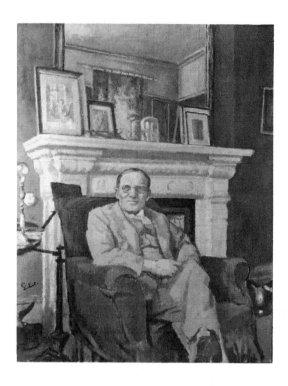

75. Walter Sickert. *Sir Alec Martin, K.B.E.* 1935. Oil on canvas, 140 × 108 cm. (55 × 42½ in.) London, Tate Gallery

Among further groups of late works is one of several self-portraits (with or without other figures), often carrying an ironic title and reminding us of Sickert's love of acting and disguise (though he is always instantly recognizable); several landscapes around St Peter's and Broadstairs; the coast at Bude, Brighton, Margate and Dover (some of these being 'Echoes', some highly contemporary); and many views of Bath, nearly all in collaboration with his wife. At his home there, as previously at St Peter's, Sickert documented his surroundings, garden and domestic arrangements as we find them described in Denton Welch's essay 'Sickert at St Peter's' or Cecil Beaton's 1940 photographs.

Until the *Late Sickert* exhibition of 1981 there had been little opportunity, since their first showing in Sickert's lifetime, to see the later paintings in any substantial numbers. In spite of its attracting one or two prophetic apologists, the work had been edited from the Sickert canon in the forty years after his death. People either followed the accepted line of dismissal or ignored it as an unknown quantity. Noted Sickert enthusiasts drew a veil over the last fifteen years of his output, though Wendy Baron wrote in 1960 that the 'Echoes' and similar works were 'perhaps the most stimulating, visually, of Sickert's entire career'. At the time of its production, however, the overwhelming reaction to the late style was one of enthusiasm tempered by a cheerful acceptance of the old artist's eccentric reliance on photography. The Victorian 'Echoes' were colourful and amusing, the full-length portraits a sensation. Press coverage was immense. Sickert was interviewed, profiled and photographed to a degree that would astonish the public of today; certainly no current newspaper would allot so much space to an eminent elderly painter and his activities. Supporters of his work included the critic T. W. Earp who wrote in praise of the 'Echoes', and the writers William Plomer, Osbert Sitwell and Hugh Gordon Porteus.

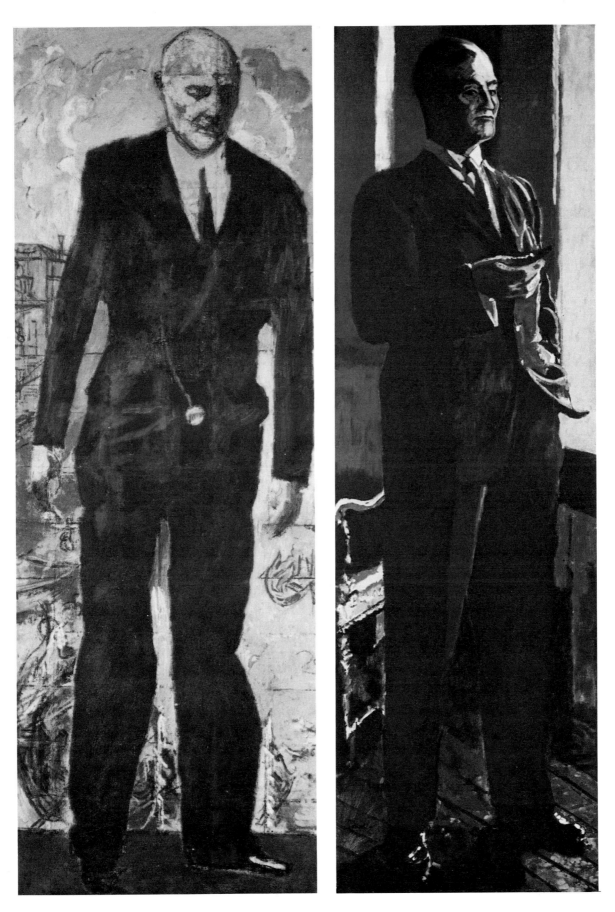

76. Walter Sickert. *Il Barone Aloisi.* 1936. Oil on canvas. Rome, Galeria Nazionale d'Arte Moderna

77. Walter Sickert. *Sir James Dunn, Bt.* 1934. Oil on canvas, 182.9 × 61 cm. (72 × 24 in.) Fredericton, N. B., Beaverbrook Art Gallery

78. Walter Sickert. *Viscount Castlerosse.* 1935. Oil on canvas, 208.3 × 69.8 cm. (82 × 27½ in.) Fredericton, N. B., Beaverbrook Art Gallery

79. Walter Sickert. *Claude Phillip Martin.* 1935. Oil on canvas, 127 × 101.5 cm. (50 × 40 in.) London, Tate Gallery

80. Walter Sickert. *Peggy Ashcroft as Miss Hardcastle in 'She Stoops to Conquer'*. c.1932–3. Oil on canvas, 127 × 71 cm. (50 × 28 in.)
Private collection

But there were voices of dissent who queried Sickert's 'second-hand' inspiration, wayward subjects and quick production line. It was the 'Echoes' in particular that caused most consternation and which, with a few exceptions, are still commonly regarded as the most intractable group of works in the late period. It seemed that in Sickert's espousal of Victorian subject matter (culled from the works of Gilbert, Kenny Meadows of *Punch*, Francesco Sargent of the *London Journal*, Adelaide Claxton and others), the artist was deliberately turning his back on modern imagery, stifling his own compositional verve and in fact playing the market for all it was worth. The pictures sold well, several going to public collections in which Sickert had not previously been represented, and were sometimes repeated by Sickert on a different scale or with different colour. It must be admitted that when a large group is seen together the effect can be dispiriting; there are several muddled transcriptions in which the original inspiration is lost, compact prints unable to bear the weight of enlargement. (This is less frequent when Sickert uses a photograph as source; there he invariably judges to perfection how big an increase in scale the document will survive.) Some of Sickert's initial relish in the situations he has transcribed wears thin and the merits of several of the black and white illustrators he praised are less apparent to less partisan eyes. What then was Sickert up to? What drew him to top hats and crinolines, to sentimental and melodramatic scenes of mid-Victorian life? There was his growing passion for the past as a natural outcome of his increasingly reactionary views. There was the highly developed theatrical instinct in his character which found pleasure in such illustrations. There was the realization that the technical methods he had evolved by the late 1920s could serve a greater range of subject matter. And there was a desire, often encountered in an artist's later work, to use colour in a more directly expressive and inventive way.

81. Walter Sickert. *Peggy Ashcroft and Paul Robeson in 'Othello'.* c.1935–6. Oil on canvas, 96.5 × 51 cm. (38 × 20 in.) Private collection

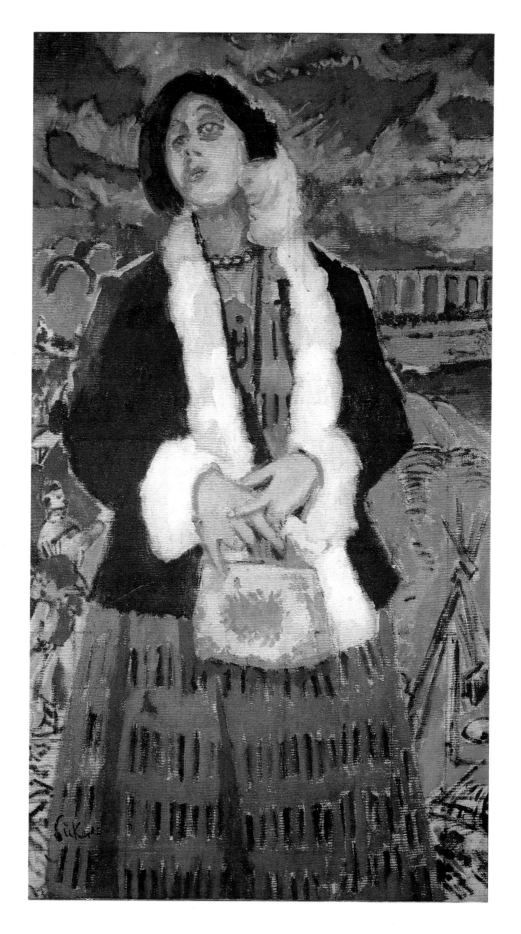

82. Walter Sickert. *Gwen Ffrangçon-Davies in 'The Lady with a Lamp'*. c.1932–4. Oil on canvas, 122 × 68.5 cm. (48 × 27 in.) Private collection

Clare Harris as Mrs. Hardcastle
Valerie Tudor as Miss Neville
Roger Livesey as Tony Lumpkin.
in
She Stoops to Conquer

Sickert – The Wells – 33.

83. Walter Sickert. *Scene from 'She Stoops to Conquer'*. 1933. Ink and watercolour, 33 × 25.5 cm. (13 × 10 in.)
New York, Collection Matthew Marks

Earlier, Sickert had perhaps become impatient with the philosophic implications of the generally low, though flexible tones of Camden Town. In Dieppe in the early 1920s he had raised the temperature with acid greens, butter yellow and sharp salmon pinks; such combinations did not, however, resolve themselves into a really personal scheme. But in some of the 'Echoes' and many late works, Sickert can be seen as a conspicuously adventurous colourist. It is true that he retains some of those favoured earlier harmonies of ochre, grey, Indian red and umber, interwoven with a range of degraded whites. But more often, we find a new sumptuousness, a broader delight in colour for its own sake. Never facile, glossy or unnecessarily various, abstemious even, it is often chalky in the higher registers, and warm in the darker areas where Sickert maintains the subtlest obliquities in a final freedom from modelling.

That the example of Venetian colour from the sixteenth century was present in Sickert's eye has often been noted. His later writings have numerous references to Tintoretto, Titian and Veronese and in 1929 he had exhibited a painting called *The Jacopo Bassano*. The early paintings of Venice inevitably recall the city of Carpaccio and the Bellini, through the familiarity of the buildings portrayed. But the more profound echoes of Venice occur in Sickert's colour, in his distance from material reality, in the often dramatic configurations of the 'Echoes' and, more so, in the theatre pictures. The well-known *Juliet and her Nurse* is close to Tintoretto's San Rocco *Visitation* in the clutching, compassionate gesture of the two figures. It is perhaps Tintoretto's late freedom of colour, the balance of neutral 'colourless' passages with discrete areas of brighter colour which Sickert most remembered. But this effect of flat clear colour with the addition of sharper accents is also the result of working from black and white photographs in which modelling was often subsumed in the brief click of exposure. This is most strikingly apparent in such a great modern portrait as *Hugh Walpole* (Pl. 69), with its superb elision and breadth of characterization.

The danger of creating a category of late work is that it tends to disengage itself from the artist's previous concerns. Such a break is more understandable with regard to Sickert when the actual look of the late canvases is so very different from the earlier ones. But the temperament and attitude remain the same. He is still ironic, cheerfully aloof, infinitely distinguished, placing trenchant detail, as before, upon simplified foundations. But through this seductive orchestration there remains as a ground swell Sickert's fundamentally tragic vision of life.

A friend of later years, Helen Lessore, once said of Sickert that 'he lived at such a pitch of awareness as if he remembered death all the time.' Sickert seems continually conscious of the passing moment, the unrepeatable instant of certain looks and gestures, and his whole elaborate procedure from first small drawing or selected photograph to final work was intended to trap such sudden illuminations. What artifice there is in that patient scrutiny of reality, drawing after drawing, to reveal just that moment in *Ennui* (Pl. 46) when the man's eyes look up beyond the confines of the room, when the woman has slumped to the level of the stuffed birds under their glass dome; to show La Carolina momentarily raise her hand to her chin, feline, suddenly self-conscious (Pl. 6); or to catch King Edward, a few weeks into a spectacularly short reign, stepping with wary half-smile from his carriage (Pl. 70). None of these is a tragic image on the grandest scale but their implications—as too in *Mamma Mia Poveretta* or, quite differently, in *Chicken*—are directed to a truth beyond that of physical, social immediacy, though all that is there and given with gusto.

Sickert's continual emphasis on tradition, on how art develops as an accumulative experience 'done in gangs', was never more forcibly expressed than in his late teaching and writings. At the same time, paradoxically, he was feeling his way towards some of his most personal and radical work. He was convinced that he was simply taking to a logical conclusion all that he had learnt. The freedoms gained from having, as it were, 'come through', show

LA LOUVE

84. Walter Sickert. *La Louve. Miss Gwen Ffrangçon-Davies as Isabella of France*. 1932. Oil on canvas, 244.5 × 92 cm. (96½ × 36¼ in.)
London, Tate Gallery

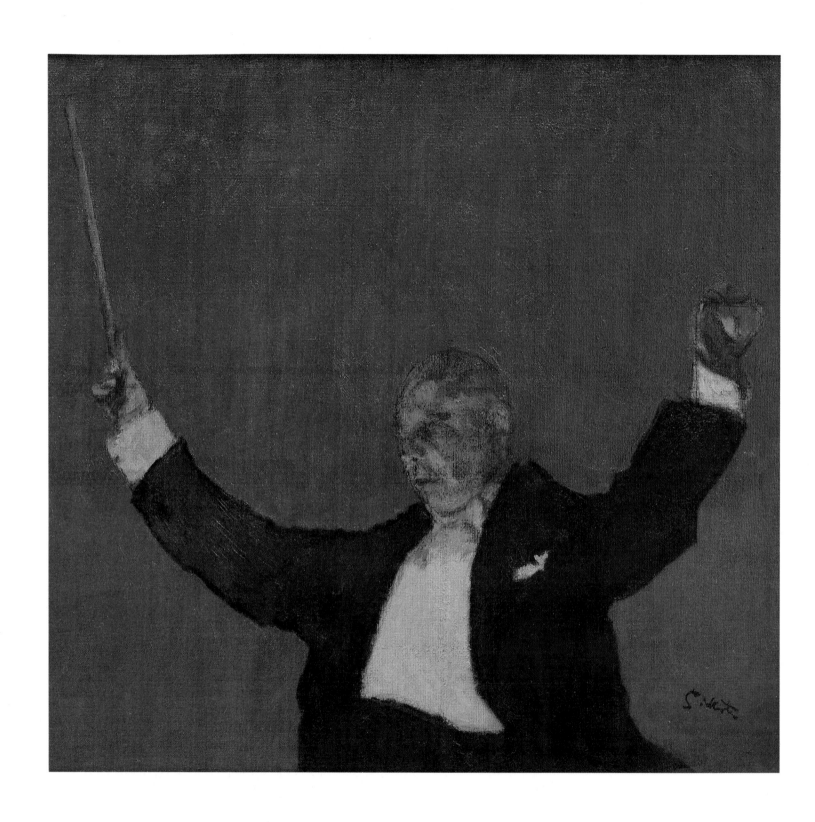

85. Walter Sickert. *Sir Thomas Beecham Conducting.* c.1935. Oil on burlap, 98.5 × 104.5 cm. (38¾ × 41⅛ in.)
New York, Museum of Modern Art

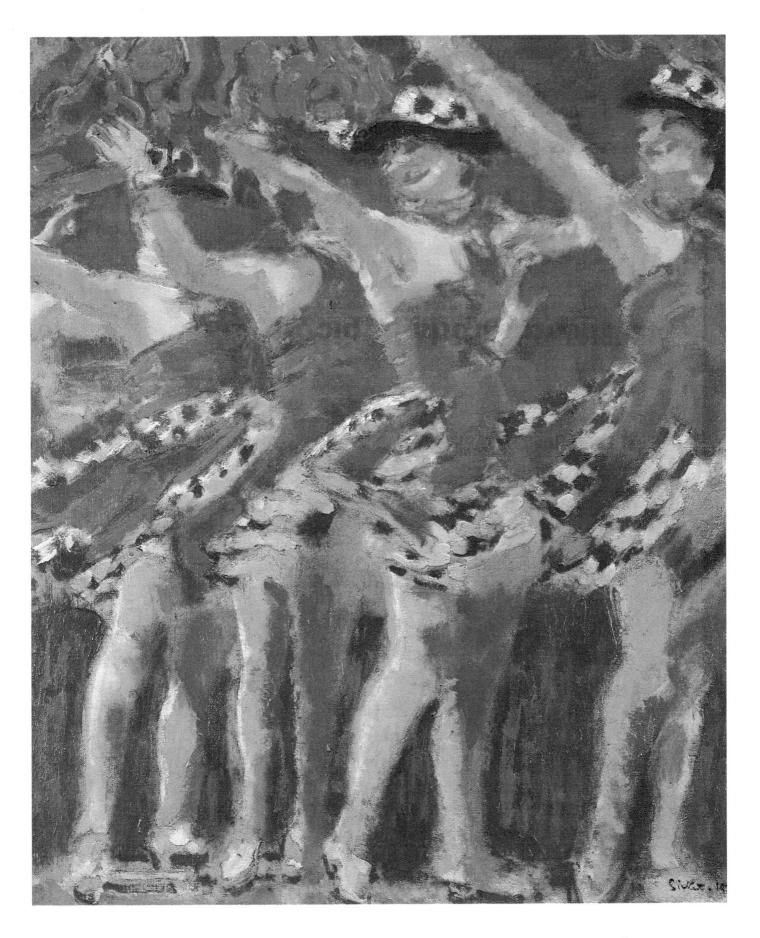

86. Walter Sickert. *The Plaza Tiller Girls.* 1928. Oil on canvas, 76 × 63.5 cm. (30 × 25 in.) Private collection

plainly enough in the 'symbolism' of the Lazarus paintings (Pls. 67, 71) and in the zest with which he tackled the seemingly unpromising material of the 'Echoes' (pages torn from the *Illustrated London News* rather than from life). As the 1930s progressed, with no slackening in Sickert's production, his methods, particularly in portraiture, became even more daring and disconcerting. While reminiscences of Degas and Whistler are retained (in the off-centre compositions, 'arbitrary' cut-off points and the tall, slim format of several single-figure works), the paintings which resulted can now be seen to foreshadow aspects of later British art, especially among so various a group of artists as Bacon and Sutherland, Kitaj and Auerbach.

Some of these precedents and similarities can best be discussed within the context of Sickert's portraits. He had long avoided society portraiture and found commissions onerous. In later years sitters took their face in their own hands, for Sickert's portraits were famously unconventional. Whether or not the works were 'like' the sitter was usually consigned to a secondary role in their public reception; it was the artist's obviously novel, apparently casual approach that caused surprise. In Sickert's earlier work there are several more formal portraits, such as the tender head of *Lady Noble* (Victoria Art Gallery, Bath) or *Mrs Swinton* (Fitzwilliam Museum, Cambridge), but all are stamped by a vision which refused current conventions. Some of his most amusing criticism is an attack on the abject commercialism of English portraiture, the rigmarole of commissions, sittings, flattery, the over-dressed supergoose 'yearning in a vacuum'. Sickert accepted later commissions only from friends or colleagues or when he wished to earn money. Several 'sitters' have recorded Sickert's unusual procedures in the making of these works. Hugh Walpole's account in his diary of 1928 is relatively straightforward and records Sickert's impatience with the lengthy sittings demanded by such portrait painters as Orpen and Kelly. 'Having got the spirit of the sitter in a drawing or two, surely they've got everything and can paint the rest as they please *when* they please. So Sickert does his little drawing, takes a photograph, and then the rest is "*his* affair," not at all the sitter's.' A decade later, and the contact with the sitter had dwindled to nothing. Sir Geoffrey Fry commissioned Sickert to paint his wife Alethea. 'Apparently, having waited some months without having heard from the artist', wrote Wendy Baron in the *Late Sickert* catalogue, 'Lady Fry was surprised one morning by a photographer who arrived to invade the privacy of her bedroom as she was reading a newspaper in bed. Then there was silence again from Sickert until Sir Geoffrey received a message to meet his wife's portrait off a certain train.' A large, coarse-grained canvas resulted, showing a fantastic vision of the startled lady, lifting the bedclothes in protection.

Sickert's life-size standing portraits such as those of Dunn and Castlerosse reflect Whistler's full-length portraits, several of which were painted with Sickert present in the studio, sometimes working from the same model. A little later there were some large portraits by Sickert of Katie Lawrence. But the late series really begins with *Rear Admiral Walter Lumsden, CIE, CVO* (Minneapolis Institute of Arts), voted Picture of the Year at the 1928 Royal Academy exhibition. Such looming images, often in brilliant colour, of figures in unconventional poses, have few precedents in modern painting. The nearest perhaps is the series by Edvard Munch, earlier in the century, of men and women standing in rooms or out of doors; they are often over life size and have a swiftly painted snapshot quality (though there appears no evidence that Munch based them on photographs, unlike other works by him of the period). It is highly unlikely that Sickert would have seen such portraits, even in reproduction, but the affinities between the open-air full-length *Jens Thiis* (1909; Kommunes Kunstsamlinger, Oslo) and several Sickert portraits (the *Beaverbrook*, for example), strikingly affirm those northern aspects of his work, so often overlooked in favour of his debt to French and Italian painting. On the other hand, Sickert's paintings of stage performances owe a direct debt to eighteenth-century theatre pictures such as those by Hogarth, Zoffany and Hayman.

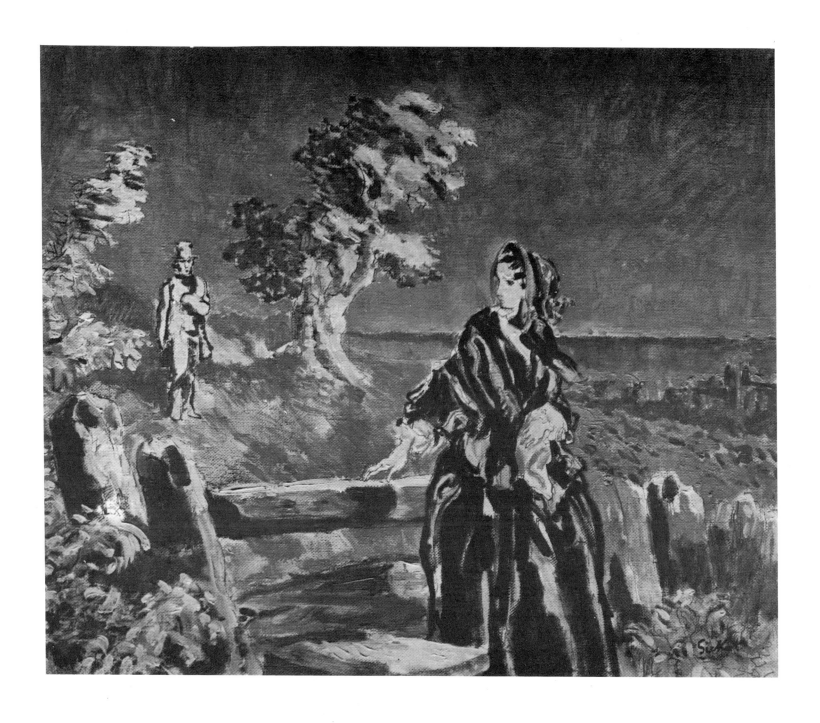

87. Walter Sickert. *Summer Lightning.* (After Sir John Gilbert). c.1931–2. Oil and pencil on canvas, 62.5 × 72.5 cm. (24½ × 28½ in.)
Liverpool, Walker Art Gallery

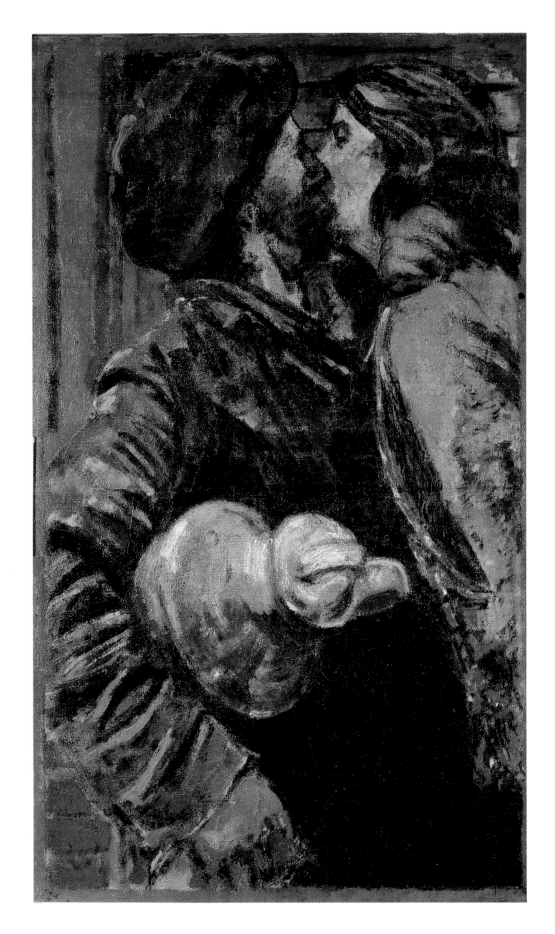

88. Walter Sickert. *The Miner. (Black-and-White)*. c.1935–6. Oil on canvas 127.5 × 76.5 cm. (50¼ × 30⅛ in.) Birmingham, City Art Gallery

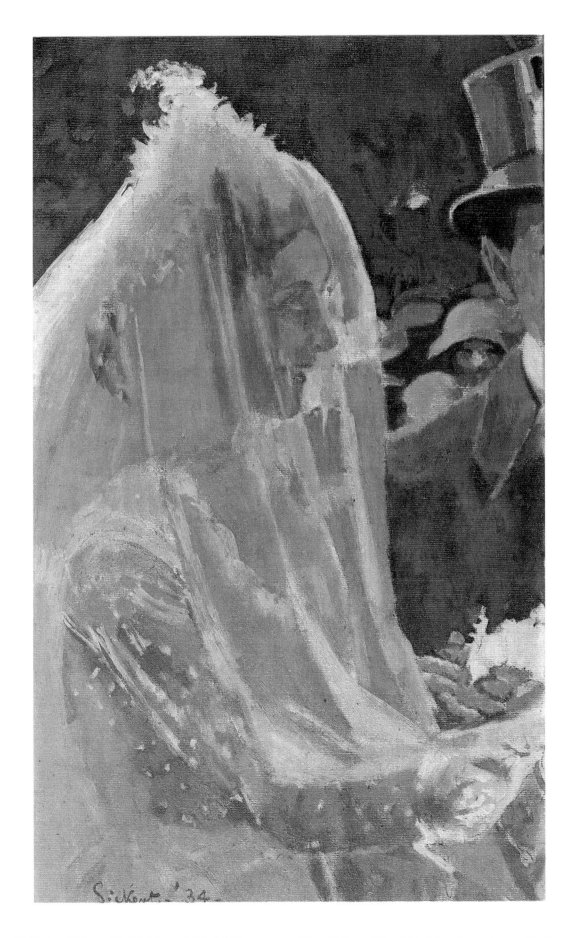

89. Walter Sickert. *The Wedding.* c.1931–2. Oil on canvas, 76 × 43.1 cm (30 × 17 in.) London, private collection

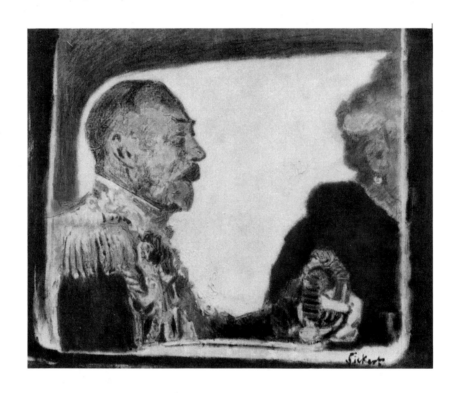

90. Walter Sickert. *George V and Queen Mary*. 1935. Oil on canvas, 63.5 × 75.5 cm. (25 × 29¾ in.)
Private collection

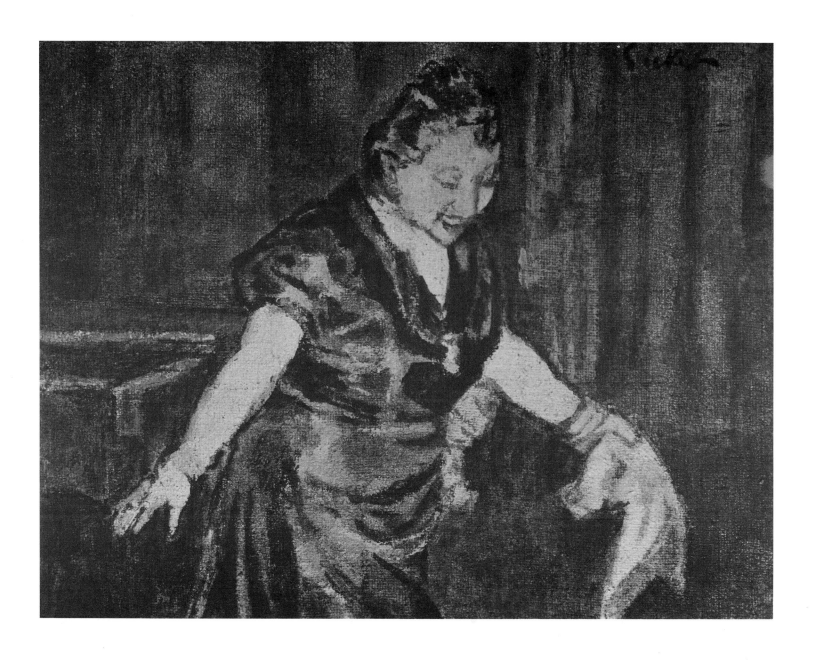

91. Walter Sickert. *Toti dal Monte.* c.1936–7. Details and whereabouts unknown

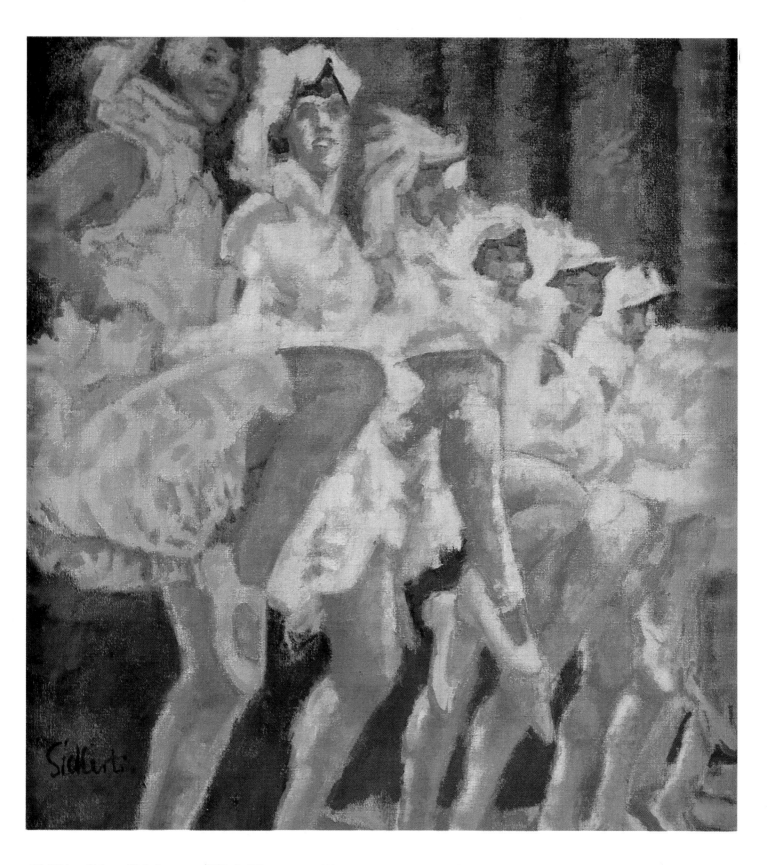

92. Walter Sickert. *High Steppers*. c.1938–9. Oil on canvas, 132 × 122.5 cm. (52 × 48¼ in.) Edinburgh, Scottish National Gallery of Modern Art

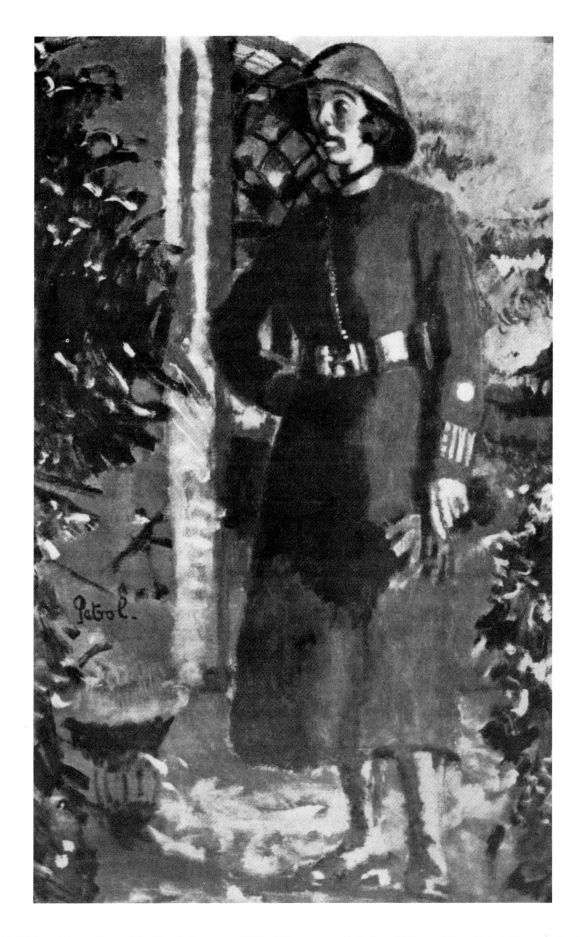

93. Walter Sickert. *Patrol. The First Policewoman.* 1930s. Oil on canvas, 185.4 × 111.7 cm. (73 × 44 in.) Private collection

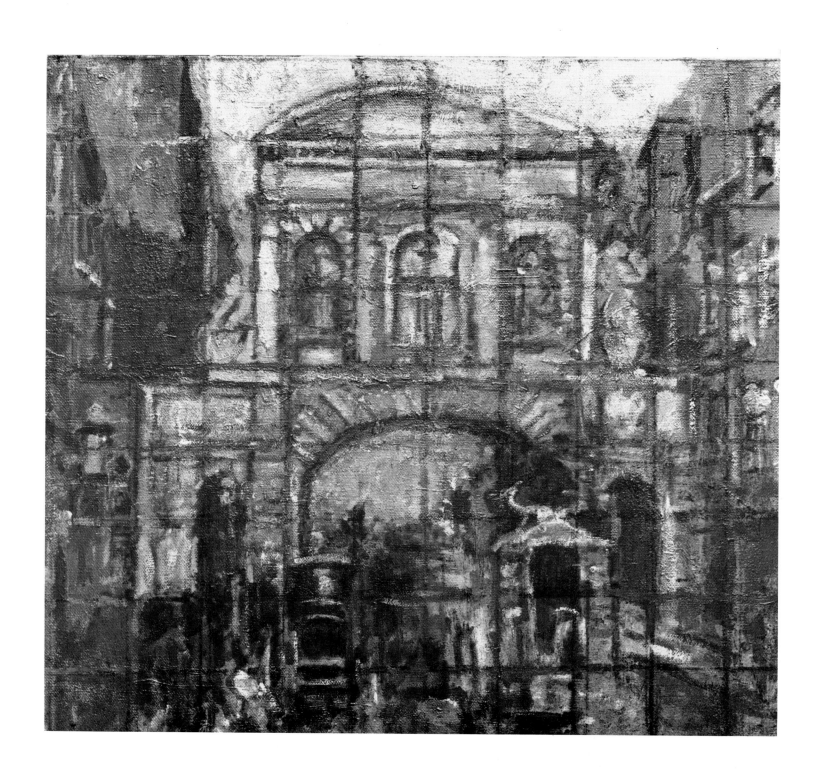

94. Walter Sickert. *Temple Bar.* c.1940. Oil on canvas, 68.5 × 76 cm. (27 × 30 in.) England, private collection

95. Walter Sickert. *In the Cabin.* c.1940. Oil on canvas, 44.5 × 80 cm. (17½ × 31½ in.) Corsham Court, Methuen Collection

One last group of 'portraits' by Sickert deserves particular notice. Sickert had drawn and painted himself from the very start of his career. There is a small ink drawing of 1882, full-face, curly-haired, a young artist's characteristic image of moody self-scrutiny. A few years later there is a shadowy Whistlerian full-length, palette in hand, the white shirt-cuff and wing-collar providing the lightest moments of the painting. A contrasting image appears ten or so years later, of a haggard and disillusioned Sickert, short-haired, mouth downturned, looking for an instant over his shoulder. A more consciously theatrical presentation is found in *The Juvenile Lead. Self-Portrait* (Southampton Art Gallery) of 1907. The title refers to Sickert's early acting career and probably to his new-found position, at the age of forty-seven, as leader of the younger artists who formed the Camden Town Group. From the same period is a large work in which Sickert is seen reflected in his studio mirror, his image placed between casts of a Venus and Michelangelo's *Dying Captive* which appear to stand on a mantelshelf immediately below the mirror; behind Sickert are the more mundane stove and floral wallpaper of his Fitzroy Street studio, a neat encapsulation, perhaps, of past and present. Shortly afterwards there comes *The Studio. The Painting of the Nude* (Pl. 36), in which only Sickert's arm and painting hand are shown, a startling device cutting across an otherwise characteristic view of the model. A pugnacious, bearded, solitary figure appears in *The Bust of Tom Sayers. Self-Portrait*, reflected in the mirror between a marble bust of the boxer and a flower vase. Self-dramatization has so far been limited to the artist in his studio, solitary and on home ground.

In the 1920s Sickert began a new phase of self-portraiture, using photographs, which project him into a variety of situations—as inveterate gambler, Lazarus, the servant of Abraham (Pl. 72), domestic bully, contented Voltairean surveying his garden, invalid (Pl. 95), public figure and ineffectual ladies' man. The three works with biblical titles come as a surprise in Sickert's development. In *Lazarus Breaks his Fast* (Pl. 71), Sickert has taken full advantage of those unexplained passages of light and dark found in photographs in which modelling is suppressed or interrupted; all is colour, applied with swift deliberation, patches of light underpainting left untouched to emphasize the figure's structure. The title's allusion is to the artist's renewed creative vigour 'as an elder of his tribe' and to a return to health within the comforts of his recent marriage. *The Raising of Lazarus* (Pl. 67), with Sickert as Christ and Cicely Hey as either Martha or Mary Magdalene, was inspired by the presence of a wrapped lay figure being carried into Sickert's studio at Highbury Place. The scene was re-enacted, a photographer present, with Sickert on a step-ladder, working his miracle from above. Enormous in scale and sharply dramatic in colour, it is one of Sickert's most impressive, if unusual achievements. It has the metaphorical and biographical implications of W. B. Yeats's later years and work, following his serious illness of 1927–8; the two men occupied analogous positions in the worlds of painting and of poetry in the 1930s, both producing controversial work in styles that fused traditional richness with sometimes stark contemporaneity. This fusion is seen at its fullest in Sickert's biblical self-portraits which include the astonishing fragment *The Servant of Abraham*, some of the theatre pictures such as *La Louve* (Pl. 84), *The Miner* (Pl. 88) with its Venetian echoes and detached passion, and one of his last works, *Temple Bar*, of around 1940 (Pl. 94). Showing Christopher Wren's London gateway in its original position, Sickert has here insisted to an unprecedented degree in revealing the methods of the picture's production. A grid of lines is imposed upon the image, veiling yet disclosing this grand salute to the monumental and the everyday, to spontaneity and artifice, to past and future.

96. Walter Sickert. *Jack and Jill* (Edward G. Robinson and Joan Blondell in 'Bullets and Ballots', 1936). c.1936–8.
Oil on canvas, 62 × 75 cm. (24½ × 29½ in.) London, private collection

Selected Bibliography

Sickert by WENDY BARON (Phaidon 1973) is comprehensive and indispensable and contains a full bibliography. Listed below are other publications frequently referred to during the writing of this book:

ANTHONY BERTRAM, *Sickert*, London, 1955
LILLIAN BROWSE and R. WILENSKI, *Sickert*, London, 1943
LILLIAN BROWSE, *Sickert*, London, 1960
ROBERT EMMONS, *The Life and Opinions of Walter Richard Sickert*, London, 1941
MARJORIE LILLY, *Sickert. The Painter and his Circle*, London, 1971
OSBERT SITWELL (ed.), *A Free House! or The Artist as Craftsman Being the Writings of Walter Richard Sickert*, London, 1947
W. H. STEPHENSON, *Sickert: The Man and his Art: Random Reminiscences*, Southport, 1940

Exhibition catalogues:

English Echoes Leicester Galleries, London, 1931 (notes by the artist)
Retrospective, National Gallery, London, 1941
Notes & Sketches by Sickert, Arts Council touring exhibition, 1949 (essay by Gabriel White)
Centenary Loan Exhibition, Thos. Agnew & Sons, London, 1960
Arts Council Centenary Exhibition, Tate Gallery, London, 1960
Sickert, Arts Council touring exhibition, 1964 (essay by Ronald Pickvance)
Sickert in the North, University of Hull, 1968 (essay by Malcolm Easton)

Since 1973, when Wendy Baron's bibliography ends, publications on Sickert (and the Camden Town Group) include:

DENYS SUTTON, *Walter Sickert. A Biography*, London, 1976
WENDY BARON, *Miss Ethel Sands and Her Circle*, London, 1977
WENDY BARON, *The Camden Town Group*, London, 1979

The following list includes exhibition catalogues, periodical literature and selections from Sickert's writings since 1973:

Sickert. Fine Art Society, London & Edinburgh, 1973 (text by Wendy Baron)
'The Modernity of Late Sickert', Richard Morphet, *Studio International*, vol. 190, July-August 1975
Sickert Etchings and Dry-points. Circulation Department touring exhibition, Victoria and Albert Museum, London, 1972–76

Camden Town Recalled. Fine Art Society, London, 1976 (text by Wendy Baron)
Sickert. Arts Council touring exhibition, 1977–78 (texts by Gabriel White and Wendy Baron)
Walter Sickert as Printmaker. Yale Center for British Art, New Haven, 1979 (text by Aimée Troyen)
The Drawings of Walter Richard Sickert. Art Gallery of Western Australia, Perth, 1979 (text by Lou Keplac)
The Camden Town Group. Yale Center for British Art, New Haven, 1980 (texts by Wendy Baron and Malcolm Cormack)
Sickert in Dieppe. Towner Art Gallery, Eastbourne, 1975 (text by Wendy Baron)
Walter Richard Sickert 1860–1942. David Jones Art Gallery, Sydney, 1980 (text by Lillian Browse)
Late Sickert. Paintings 1927 to 1942. Hayward Gallery, London, and Arts Council tour, 1981 (texts by Frank Auerbach, Helen Lessore, Denton Welch and Wendy Baron)
Sickert. Browse & Darby, London, 1981
Walter Sickert and Jacques-Emile Blanche and friends in Dieppe. Michael Parkin Gallery, London, 1982
Spencer Frederick Gore. Anthony d'Offay, London, 1983 (texts by Richard Shone and Frederick Gore)
Sickert and Thanet. Paintings and Drawings by W. R. Sickert 1860–1942. Ramsgate Public Library, 1986 (extracts from Sickert's Thanet School of Art lectures, 1934, edited by Paul Pelowski)
Walter Richard Sickert. Advice to Young Artists. Norwich School of Art Gallery, 1986 (extracts from Sickert's writings and lectures edited by Lynda Morris)
'Some Memories of Sickert', Quentin Bell, *The Burlington Magazine*, vol. cxxix, April 1987

Among books on the English music hall, the following have been particularly useful:

COLIN MACINNES, *Sweet Saturday Night*, London, 1967
W. MACQUEEN-POPE, *The Melodies Linger On*, London, 1950
RAYMOND MANDER and JOE MITCHENSON, *British Music Hall*, London, 1965
HAROLD SCOTT, *The Early Doors*, London, 1946

The author has also consulted the extensive collection of Sickert documents, letters, catalogues and press-cutting books held by the Islington Public Libraries.

INDEX

The figures in **bold** are plate numbers.

97. Sickert in his Studio at 1 Highbury Place, London. c.1928–30. Islington Public Libraries